LEICESTER
in the 1970s
Ten Years That Changed a City

STEPHEN BUTT

AMBERLEY

First published 2015

Amberley Publishing
The Hill, Stroud
Gloucestershire, GL5 4EP

www.amberley-books.com

British Library Cataloguing in Publication Data.
A catalogue record for this book is available from the British Library.

ISBN 978 1 4456 4062 4 (print)
ISBN 978 1 4456 4081 5 (ebook)

Typesetting and Origination by Amberley Publishing.
Printed in Great Britain.

INTRODUCTION

The 1970s have been described in various ways. To some, it was the decade of bad taste in respect of how we dressed, what we chose to eat and how we decorated our homes. It was memorably described as the 'Me Decade' by the American author and journalist Tom Wolfe, who saw how the growing desire to acquire more wealth and assets conflicted with a rampaging inflation rate in Britain and a global oil crisis. It was certainly a decade characterised by industrial disputes, caused by the high inflation rates and the consequent growing unemployment.

In the first months of 1974, a strike by British miners forced the Conservative government to call a 'three-day week' and to instigate programmed power cuts across the country to reduce energy consumption. Leicester's manufacturing industries were only able to operate for three days in any seven, leading to reductions in output and less work for those thousands of Leicester's workers who were dependent upon these industries. Other strategies introduced by the government to conserve power station reserves included shutting down the nation's television services at 10.30 p.m.

In the following year, the UK inflation rate peaked at 26.9 per cent. The relationship between the unions and the government deteriorated to such an extent that widespread strikes in the public sector, coupled with the coldest winter for many years led, to the industrial actions of the 'Winter of Discontent' of 1979 and ultimately to the demise of the Labour government under James Callaghan.

Beckett's Buckets, Charles Street: Over the years, most of these concrete troughs bearing the Leicester coat of arms were removed during alterations to Charles Street, but these remain. They were first installed during the era of former borough surveyor John Beckett.

The hiking of prices by the major oil producers led to further stringencies. The United Kingdom and the rest of Europe were particularly dependent upon oil supplies from the Middle East. In response to the sudden increase by the Organisation of the Petroleum Exporting Countries (OPEC), many countries introduced car-free days or banned the use of cars at weekends. However, the growing realisation that oil reserves were not limitless and could not be relied upon to supply future energy needs led ultimately to the growth of ecological awareness and 'green' politics, a movement that was to find its place in national politics and world affairs in future years.

If the 1950s had been a time of rebuilding, and of thoughts of home, and the 1960s had heralded a period of reform, of challenging of established traditions and of social progressive thought, in the 1970s the international agenda and elements of world vision came to the fore once again. The United Kingdom joined the European Union, and our currency, which had evolved over many centuries, was changed to the decimal system which was already in use across Europe.

Another of the social challenges of the previous decade, the liberty and status of women, continued to grow in importance. Although age-old sexism was still deeply ingrained in popular culture, changes were taking place. Perhaps the most remarkable example of the rate of change of attitudes was the general election of 1979 which resulted in Margaret Thatcher becoming the first (and to date only) female British Prime Minister.

Science and technology led to numerous innovations in the 1970s, many of which were to transform the lifestyles and aspirations of millions of people. Microwave ovens and video recorders became available for the domestic home market, Motorola

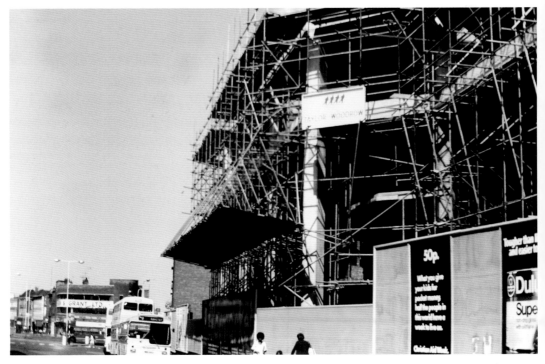

Haymarket Theatre: The theatre under construction in July 1972, looking along the Haymarket towards its junction with Belgrave Gate and Charles Street.

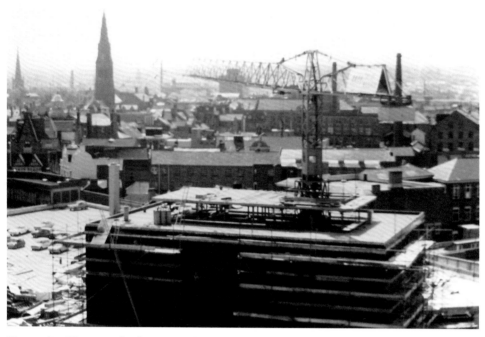

Haymarket Theatre: The fly tower of the Haymarket Theatre being constructed in July 1972. The spires of Leicester Cathedral and St Mary de Castro are dominant on the skyline.

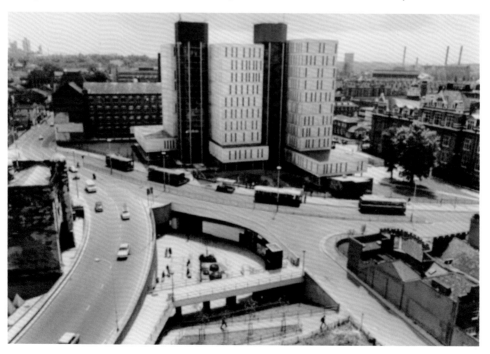

Southgates Underpass, 1974: The medieval Magazine (or Newarke) Gateway was surrounded by the traffic system of the Central Ring. The ill-fated subway has since been filled in, and the James Went Building of De Montfort University (centre) has been demolished. (*Leicester Mercury*)

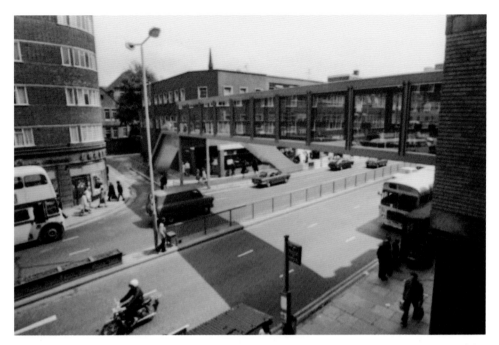

Charles Street Bridge. The pedestrian bridge over Charles Street, built in 1973 as part of the Haymarket Centre project, was an attempt to separate pedestrians from traffic. After being closed for several years, it was finally removed following complaints about vandalism and antisocial behaviour.

transmitted a telephone call from the first mobile phone in 1973, and in 1978 the first Sony Walkman was built. The Apple Computer Co. was set up in a garage in Los Altos, California, in 1973, and the Xerox Alto, in the same year, became the first computer to use a 'desktop' and a mouse-driven graphical user interface.

But for most households, technology was simple. The digital age was still at least a decade away. In most homes, one telephone attached by wire to a box on the skirting board served as the only means of communication for the entire family, and in almost all shops, purchases were paid for in cash. The first Automated Telling Machine (ATM or 'hole in the wall') was brought into use by Lloyds Bank in Brentwood, Essex, in 1972, although there had been some experimental machines in operation for the past decade.

The rubbish of the 1970s was not segregated into plastic wheeled containers of different colours but simply all placed in the aluminium dust bin at the bottom of the garden, collected weekly by the 'dust man'. There were few concerns about the effect on the environment of the increase in pre-packaging and 'disposable' materials, and environmental pressure groups such as Greenpeace were either not known to the general public or regarded as trouble-making activists. Risk assessments and concepts of health and safety at home and in the workplace were still in their infancy: one of the statistics cited in descriptions of the building of the world's first reversible-turbine power station (at Cruachan in Scotland), along with its generating capacity and the amount of water held in its loch, is the fact that thirty-six men died during its construction. Such a statistic would provoke, justifiably, considerable outrage in the present day but death and serious injury in Britain's manufacturing and production industries was still, sadly, a fact of life in the 1970s.

New Walk Centre: Inappropriate in scale and architectural style, given its proximity to the eighteenth century New Walk and nineteenth century shops, the New Walk Centre became the headquarters of Leicester City Council in 1975 when no other buyer could be found. It was demolished by controlled explosions in 2015 after being declared structurally unsound.

After the excitement of Neil Armstrong's 'one small step' on the moon on 21 July 1969, the near loss of the Apollo 13 astronauts in April 1970 added to a growing feeling in the United States that too much money and resources were being spent on manned space missions. As a consequence, the final planned Apollo launches were scrapped, and the hardware was used instead on the Skylab space station programme of 1973/74 and eventually in the development of the space shuttle.

The Local Government Act of 1972 changed the political geography of the United Kingdom. The county of Rutland, England's smallest county, was abolished, becoming part of the county of Leicestershire although its inhabitants remained fiercely independent and campaigned vigorously for repeal which came eventually in 1994. In terms of managing services and planning its future development, the city of Leicester lost statutory powers under these 'reforms'. The Act, which became law in April 1974, effectively merged Leicester and the County of Rutland with the County of Leicestershire. Services including education, museums and libraries were combined somewhat uneasily under single directorates based at County Hall.

If you were male and an adult in the 1970,then, statically, you smoked heavily, you did not go to university and you didn't go abroad for your holidays. You were more likely to have a job in a factory than anywhere else, and it was unlikely that you would live beyond the age of sixty-eight. If you were female then you were most likely to have had your first child by the age of twenty-five, and you would have been spending 20 per cent of the family income on food, not on energy bills as became the situation in later decades.

In 1970, when Edward Heath had just become Prime Minister and the Beatles were breaking up, for men, life expectancy was 68.7 years and for women it was seventy-five years. In the twenty-first century, these figures have improved considerably.

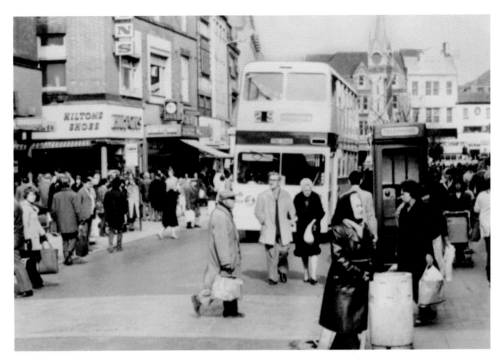

Gallowtree Gate, 1975: The first steps towards the pedestrianising of the city centre took place in the 1970s. There is a clear conflict between public transport and the public. Initially, only private cars were banned from the street.

An accident at the Magazine Gateway, 1972: Having surrounded the medieval Magazine (or Newarke) Gateway with the newly constructed Central Ring, it was perhaps inevitable that a vehicle would come off the road at this location. (*Leicester Mercury*)

Gallowtree Gate, 1970: Looking south towards the junction with Halford Street and Horsefair Street, Marshall and Snelgrove's department store (formerly Adderlys) is empty. Next door, towards the camera, is the Leicester-based shoe manufacturer and retailer, Stead and Simpson.

In 1974, 24 per cent of men and 13 per cent of women who smoked regularly were classed as heavy smokers, whereas in 2015 the figures are 7 per cent of men and just 1 per cent of women.

In the academic year from September 1970, there were 621,000 students in higher education in the United Kingdom compared with more than three million in 2015. In 1978, the manufacturing sector accounted for nearly three in ten jobs in the United Kingdom, but this fell to 10 per cent (the lowest proportion since records began) in the first decade of the twenty-first century. In 1970, many households in Britain did not have the regular use of a car. Food and non-alcoholic drinks was the largest category of expenditure.

Statistics are interesting but without context can be uninformative. This book sets out to describe and understand how we lived in Leicester in the 1970s, our quality of life, what we believed in and aspired to, and how day-to-day life influenced those aspirations.

In summary, the 1970s was a major turning point in the way we viewed ourselves and the world. We had for too long been complacent, enjoying the warm glow of post-war affluence, not realising that the world around our small island was changing, and that our foreign competitors, many of whom had seen their economy and manufacturing base devastated by the Second World War, had not only caught up with us, but were leaving us behind.

British Steam Specialties: Founded in 1899, BSS, with its base in Lee Circle, was thriving in the 1970s and rode out the economic storm of that decade. In 2015, the company moved to an out-of-town site and is still a market leader of national renown.

Norman & Underwood Ltd Advertisement: Established in 1825, Norman & Underwood has been involved in the construction of numerous landmark buildings in Leicester over almost two centuries.

Morgans Locksmiths Advertisement: An advertisement from the 1970s for one of Leicester's oldest businesses, founded in 1717. Morgans now operates from premises in Saffron Lane.

1

Leisure

Leisure and recreation were still emerging concepts in the 1970s both in terms of commercial and statutory provision. Their association with public health lacked positive marketing, and we were therefore seldom encouraged to 'keep fit', or to live healthily.

The city and the county authorities still maintained their parks and open spaces, museums, libraries and public baths, but there was little new investment in any of these provisions with the exception, in the city, of the Saffron Lane Velodrome. This 3,100 seat facility was built in 1978 and, at the time, was a nationally recognised state-of-the-art cycling track attracting top cyclists from all over the country. At the centre of the track was an all-weather pitch which was for some years the home of the Leicester Panthers american football team. It is ironic that civic interest in this facility diminished in later years at the very same time that the public's enthusiasm in cycling as a recreational and 'green' pursuit began to increase. Possibly the most modern and well-equipped recreation facility in Leicester during the decade was the St Margaret's swimming baths which had opened in 1966, but it would be some years before out-of-town leisure centres such as at Beaumont Leys and Aylestone would be constructed.

In 1974, changes in the structure of local government in the United Kingdom led to the merger of many services which until then had been managed separately by Leicester City Council and Leicestershire County Council. These included those amenities which were later to come under the banner of leisure, heritage and well-being.

It was an uneasy merger which caused disunity among the staff and, on some occasions, an element of hostility, as policies conflicted. The merger of the libraries and the museums and records services of the city and the county led to the creation of two of the largest directorates of their kind outside London, becoming the Leicestershire Libraries and Information Service and the Leicestershire's Museums, Arts and Records Service.

In 1971, under the directorship of Geoffrey Smith, and in a partnership with the distinguished historian Professor Jack Simmons of the University of Leicester, Leicestershire County Council reprinted John Nichol's important *History and Antiquities of the County of Leicester*. The original version had been completed in 1815 and ran to eight volumes containing more than 5.5 million words. It was decided that the 1971 reprint would be an exact reproduction of the original with nothing omitted and no revisions or amendments except for a new Introduction by Professor Simmons. At a time of high inflation, the cost of the project was questioned but was finally approved. It led the way for other library services across the United Kingdom to reprint their own county histories but none matched the scale of the Leicestershire project.

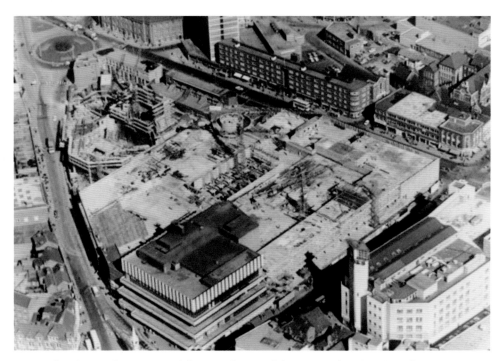

Haymarket Centre Construction: This aerial view of the Haymarket Centre under construction in 1972 indicates the scale of the redevelopment reaching from the clock tower to Charles Street. Numerous Victorian and Edwardian buildings were demolished.

Parks and Open Spaces

Leicester City Council in the twenty-first century now manages no fewer than 130 separate parks and open green spaces, but in the 1970s, the number was far smaller and the approach to caring for them was very different.

Biodiversity, conservation and a scientific approach to the management of green spaces were not on the agenda of the parks department in the 1970s. The parks of this period and the way they were supervised echoed the practices of the Victorian era when the oldest of the city's open spaces had been laid out and landscaped. As in the case of Leicester's Abbey Park, they had been 'designed' in order to provide exciting and surprising views. Lakes had been excavated and the spoil used to create artificial embankments. Even the planting was 'unnatural' in that foreign species of trees and shrubs were intermixed with native plants.

However, by the 1970s, the high cost of maintaining numerous flower beds and greenhouses was mounting and resulted in a reduction in standards of maintenance. Park buildings such as cafes were given inexpensive 'makeovers', which paid little respect to their architecture and historic significance, or were simply closed and used as storage areas.

Certainly, Leicester's parks were enjoyed by many during the decade despite the rise in ownership of cars which enabled families to seek recreation further afield. When the sun shone, the city's parks were enjoyed by many residents, but the protection of wildlife, the conservation of natural habitats, and a general desire to enjoy and respect nature were all concepts yet to be discovered by most people.

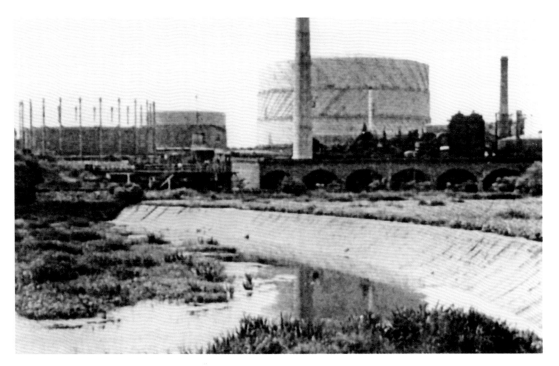

Freemans Weir: This photograph, taken by the Inland Waterways Association, demonstrates the problems confronted by those who wanted to use the River Soar and canal through Leicester for recreational purposes in the 1970s.

The City of Leicester Show

Just as the July Industrial Fortnight marked the beginning of summer for many thousands of Leicester people, the City of Leicester Show signalled the end of the lazy hazy days and the beginning of the autumn season.

Historically, the City of Leicester Show was the development of an earlier Annual Flower Show which had been staged in Abbey Park on a regular basis since the nineteenth century and had incorporated, in its earlier days, a swimming gala. By the 1940s, the show had evolved gradually into an event with broader appeal, but with the horticultural elements still at its heart, housed in several large marquees. The show, also familiarly referred to as the 'Abbey Park Show' was held in Leicester's largest green open space on the late Summer Bank Holiday Monday and the following day. In later years, because of many local inhabitants having to return to work on the Tuesday, it was moved back one day to the Sunday and Bank Holiday Monday.

Abbey Park was an ideal venue for the show, with its wide tarmac paths, excellent drainage and space for hundreds of vehicles. It enabled the organisers to create separate areas for different activities including showjumping, fairground rides, commercial stands, music, entertainment and community-based activities. The size of the park, fifty-seven acres, meant that even with over 50,000 people attending, there were still quiet open spaces for relaxation in relatively peaceful surroundings.

It was organised and paid for by Leicester City Council and managed by the council's entertainments manager who, during the 1970s, was based in a small office in the De

EXPO at the City of Leicester Show: In 1972, Leicester promoted its business and economic resources with a five-day festival following on from the annual City of Leicester Show at Abbey Park. The event included a 'Great Tent Show' directed by Ken Armitage, from which an EP record was produced.

Montfort Hall. Because it involved numerous Council employees including the parks staff and transport departments, it was always a costly event for the council, and rising costs year-on-year led in part to its final closure in 1995. In the 1980s, in the view of some who attended, the event became somewhat politicised, with an area of the park set aside for groups with specific campaign agendas such as Campaign for Nuclear Disarmament and ecological campaigners. Critics also saw 'sameness' in the attractions that were provided, despite a steady annual increase in the admission charges. The British weather also played a part in its demise with several shows washed out by heavy downfalls of rain.

The horticultural show has continued and is now held at the Aylestone Leisure Centre, annually on the late Summer Bank Holiday, managed by the Leicester and Leicestershire Horticultural Judges Guild. In 2015, the elected mayor of Leicester, Sir Peter Soulsby, announced that the old city show could return but in a different form that would be appropriate to the twenty-first century.

Allotments

One of the recreational activities fostered by the City of Leicester Show was the growing of fruit, flowers and vegetables. The horticultural tents displayed many hundreds of examples of produce grown in the gardens and allotments in Leicester. Yet, this was actually an activity that was in decline and had been for decades.

Although some of the larger allotment sites in Leicester had been laid out in Victorian times, and were to some extent an echo from as far back as the ridge and furrow of the countryside, and the desire of many to cultivate their own land, the need for new housing in the post-war decades led to a significant reduction in the amount of land available. The number of plots declined steadily and continues to decline in the twenty-first century.

The Thorpe Enquiry of 1969 investigated the decline and decided that the principle causes were the reduction in available land due to pressure from housing developments,

increasing prosperity and the growth of other leisure activities. The final report also pressed for legislation to protect the remaining land.

An increased interest in green issues in the 1970s revived interest in allotment gardening, encouraged by the National Society of Allotment and Leisure Gardeners, and the decline in the loss of plots began to slow; but by the end of the decade, there were 33,000 less plots available nationally and a rising waiting list.

However, the concept of living healthily by growing one's own fruit and vegetables, with the ability to limit the application of pesticides and to encourage a diversity of crops, was still in the future, or perhaps in the past. Some of the larger industries still provided allotment plots for their employees, but it was the older generation who would devote their free time to such an occupation.

The Home Life Exhibition

A development of London's Ideal Home Exhibition, which had been staged annually in the Earls Court arena by the *Daily Mail* newspaper, the regional Home Life Exhibition brought new ideas and innovations to the homeowners of Leicester.

It had begun in 1923, offering the latest in fads and fashions, kitchen accessories, furniture and electrical goods. Across ten days each year, it attracted large numbers of Leicester people to the Granby Halls. In the 1950s, it was also a place where the first Battalion Leicestershire Home Guard would have a stand for the purposes of recruitment. In the 1970s, British Broadcasting Corporation (BBC) Radio Leicester would regularly broadcast live from the show, and ATV, the independent television company for the area, would film the latest gadgets. Archive footage from the time includes film of a display of working models by the Leicester Society of Model Engineers, caravans on sale and a demonstration of a new electrical tool for digging gardens.

In 1979, Royal Mail, as in some previous years, set up a stand at the exhibition from which visitors could post letters bearing the unique franking '48th East Midlands Home Life Exhibition, 15 September 1979, Granby Halls, Leicester'.

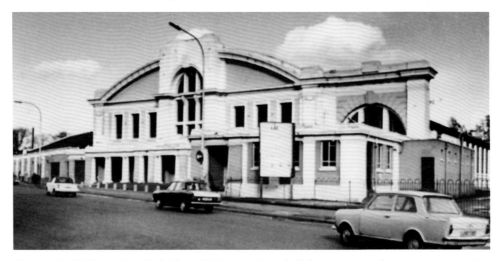

The Granby Halls: Originally built in 1915 as a training hall for young people entering war service, and extended later, the Granby Halls provided almost 30,000 square feet of covered recreation and exhibition space. The amenity was still thriving in 1979 when this photograph was taken.

The Leicester Amateur Radio Show

In the days before the internet and digital communication, amateur radio was a very popular means of contacting likeminded individuals across the world using various forms of wireless transmission. The image so graphically and amusingly presented by the comedian Tony Hancock in his sketch originally broadcast in 1956 was an unfair representation of a very large number of very professional, intelligent and skilled operators. Amateur radio enthusiasts in the 1970s used short-wave radio frequencies (as did the BBC's External Services), but today sophisticated technologies allow communication with International Space Station and the use of a very wide range of frequencies in the broadcast spectrum.

In Leicester in the 1970s, the 'radio hams' met annually at the Granby Halls as the Leicester Amateur Radio Society, which had been formed in 1913, where they demonstrated their communication techniques in front of visitors.

The International Air Display

A remarkable sequence of international air displays took place in the 1970s and the following decade at the relatively small airfield located near Stoughton, south of Leicester, constructed in 1942 and originally known as Royal Air Force (RAF) Leicester East.

The shows were organised by the Leicester Aero Club, which had been founded in 1910 and included Amy Johnson and the former Prince of Wales among its earlier members. Taking place on the late Summer Bank Holiday each year, the shows featured both the smallest light aircraft and the most up-to-date military jets, each appearance described in detail through a public address system. On one occasion, a Concorde made a flypast, and on another occasion a Russian-built Antonov, one of the largest aircraft ever built. Other regular attractions included the popular Avro Vulcan XH558 and the Avro Lancaster with the Battle of Britain Memorial Flight. The famous Red Arrows usually concluded the event with their familiar formation flying displays.

In 1978, rehearsals took place in preparation for a special event designed to commemorate the sixtieth anniversary of the RAF. Attendance increased year by year and by 1980, when the display of that year marked the fortieth anniversary of the Battle of Britain, it attracted over 60,000 visitors. A one-way system was arranged in the narrow roads that provided the only access to this rural location, and young members of various local Air Training Corp squadrons worked voluntarily on crowd fencing and car parking.

Toys and Games

Technological breakthroughs in the manufacturing processes involving plastics, in which the Leicestershire-based Palitoy Co. was a leading British pioneer, led in the 1970s to a new range of toys, very different from the 'Meccano' generation of previous decades. Almost all the most popular toys of the decade were based on plastic moulding.

In 1974, the Hungarian sculptor and Professor of Architecture Ernő Rubik invented his magic cube, later to be known worldwide as 'Rubik's Cube'. Creating and manufacturing this disarmingly simple toy was actually a complex mathematical challenge for Rubik.

The revolution in plastics also led to the concept of action figures derived from popular films. One such brand, and the most successful, has been the *Star Wars* films which began

with the original film released on 25 May 1977. The robots – R2-D2 and C-P30 – were immediately successful as action toys, as was the first of many board games based on the franchise, Star Wars: Escape from the Death Star, released in the same year as the film.

Other plastic-based games and toys included Spirograph, based on a concept that had been devised in the nineteenth century but developed in the late 1960s by Denys Fisher initially using components from a Meccano set. In 1970, the toy was sold by Fisher, to Palitoy, based in Coalville in Leicestershire.

Palitoy also created Pippa Dolls in the 1970s. Launched in 1972, Pippa was a pocket-sized fashion doll with many friends and fashion garments from minidresses to formal attire and outfits linked to different jobs. Later in the decade she acquired an apartment, her own hair salon and a car.

Reflecting the changing cultural diversity of the United Kingdom, Palitoy added a black friend by the name of Mandy and an Asian friend called Jasmine. Her first three friends were Marie, Tammie and Britt, and later these were joined by Penny, Rosemary, Emma, Gail and Pete the boyfriend.

The imaginative Palitoy Co. was also responsible for a 'doll for boys' in the form of Action Man. He was based on the American Hasbro G.I. Joe of the previous decade, but from 1970 onwards Palitoy sought to differentiate their product from its American origins by adding sporting and adventure themes to the basic 'military' concept. One of the Action Man lines created by William Pugh, the head of Action Man's product development at Coalville, was the range of ceremonial uniforms which even included a horse as part of the life guard's kit.

The East Midlands-based Raleigh Bicycle Co. revolutionised the design of children's bicycles with the launch of the Raleigh Chopper. Originally released onto the market in 1969, a modified version was launched in 1972. Despite being a phenomenally successful bicycle in terms of worldwide sales, it was heavy and difficult to ride; but it led the way to a new generation of design with models such as the Raleigh Chipper, Tomahawk, Budgie and Chippy.

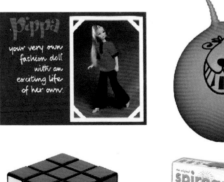

Four popular toys of the 1970s: Pippa, the fashion doll, and Spirograph, both by Leicestershire's Palitoy Company, Rubik's iconic cube and the Space Hopper.

The decade saw the production of the first mass-produced electronic games, creating an industry which was to grow dramatically in the digital age. The original Atari computer game was launched in 1972 using technology from arcade games. The name derives from a Japanese term used in the ancient board game 'Go'. Working at the forefront of the new technology, the small Atari Co. faced remarkable technical challenges, beginning with a coin-operated machine derived from a black-and-white television set, the mechanism from a Laundromat washing machine, and a plastic cup to catch the coins. They realised that they had created a successful project when queues formed outside the venue in which it had been placed and the machine broke down because it couldn't accommodate the amount of money it was receiving. Atari developed their concepts steadily. The Atari 2600, released in October 1977 as the Video Computer System, became one of the most successful consoles in history.

A toy that appealed to the more energetic youngster was the Space Hopper, which first appeared in the United Kingdom in 1969 having been invented by an Italian company which manufactured rubber balls. A fine example of lateral thinking in design, the Hopper was basically a large rubber ball shaped so it could be sat on. It became an instant marketing success and launched a craze which continued for two further decades. Space Hoppers were even to be seen in an episode of the American science fiction series *Star Trek* in 1968, a year before their British launch, and later in an edition of *Friends*. They were even to feature at the Glastonbury Festival and the BBC comedy series *The Goodies*.

But the more traditional toys of past generations were still popular. Marbles, Meccano, electric train sets by Hornby and Triang and roller skates which could be worn over ordinary shoes were all to be found in toy cupboards of the time.

The addictive pocket board game Mastermind was also a Leicester product of the 1970s. The game was invented by an Israeli postmaster and telecommunications expert and licensed to Invicta Plastics, based then in Oadby, who launched it in 1971.

By chance, Bill Woodward, a hairdresser from the House of La Croix in Leicester, known locally as Mr Teasy-Weasy, became one of the world's most familiar faces by appearing on the lid. He took part in the photoshoot for the Mastermind box because a male model recruited by an advertising agency friend had failed to show up. The female model was Cecilia Fung, a student at Leicester University. The photograph became one of the world's most ionic and enduring images.

From 1977, Invicta also manufactured handheld electronic versions of the game, although these were made in Hong Kong and not in the United Kingdom. The deluxe version included sounds and a timer. In the following year, the company won the Queen's Award to Industry for Export Achievement because of the huge success of Mastermind. The game is still on sale but is now manufactured under licence by Hasbro in the Far East.

Books

As with so much of the culture of the 1970s, it is difficult to define a specific style or trend in writing that can be associated precisely with this decade, although perhaps the best-selling books were less 'worthy' and less instructional than those that had sold well in previous years.

Horror was a very successful genre of the period. In 1971, *The Exorcist* by William P. Blatty was published, rivalled in terms of sensationalist popularity by Jay Anson's *Amityville Horror* in 1977. At the end of the decade, Stephen King made his debut in the

top ten best sellers with *The Dead Zone*, having already published *Carrie*, *Salem's Lot* and *The Shining*.

Of a totally different style, in 1975, Richard Adams produced the ever-popular *Watership Down*, and old-fashioned storytelling was reborn with Eric Segal's *Love Story*. It was also a time when the storytellers of the past, including Agatha Christie, J. R. R. Tolkien and Virginia Woolf, were celebrated with major biographies, but perhaps the most significant and best-selling non-fiction work of the entire decade came in 1974 with *All the President's Men*, the expose of the Watergate Scandal and Richard Nixon by journalists Carl Bernstein and Bob Woodward.

Sue Townsend, one of the most successful writers to come from Leicester, was yet to invent the character of Adrian Mole. In 1978, in her early thirties, she joined a writers' group at the Phoenix Theatre in the city; although in the first sessions she was too shy to speak. She was set the challenge of writing a play in two weeks. The result was *Womberang*, published in 1979, a thirty-minute drama set in the waiting room of a hospital gynaecology department. She later became writer-in-residence at the Phoenix.

The New English Bible was, by sheer quantity, the best-selling book of the decade. Although the New Testament had been published in 1961, the work, including the Old Testament and the Apocrypha, was not completed until 1970.

In 1978, a new daily newspaper was launched. The *Daily Star* was the first new tabloid to be launched in the United Kingdom since the *Daily Worker* in the 1930s. The paper was launched from Manchester, using spare capacity at the *Daily Express* printing presses in that city, and was originally only circulated in the North and Midlands. Its mix of celebrity, sport and glamour found an immediate market, with all 1.4 million copies of its first issue selling out.

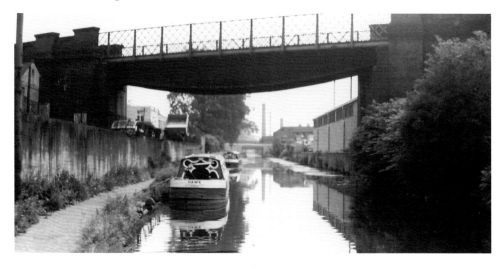

Leicester's Waterside: The canalised section of the River Soar through Leicester in the 1970s with echoes of its industrial past, and before conservation and environmental projects began to take effect.

2

SPORT

For those who followed the fortunes of Leicestershire's three major sporting activities, this was an exciting and entertaining time. The Foxes, the Tigers and Leicestershire County Cricket all achieved very considerable success, and in all three instances this was due to the inspiration and dynamism of the men 'at the top', the managers, trainers and coaches. Common to Filbert Street, Welford Road and Grace Road was the golden rule that inspiring good players produced good games which attracted increased attendances, which in turn gave the clubs more buying power to enrich their teams.

Other sporting activities fared differently. It was the beginning of the end of the track for speedway in Leicester, and this was the last decade when boxing and wrestling could be described as truly popular local spectator sports.

Football

Leicester City Football Club had experienced mixed fortunes in the 1960s with relegation to Division Two, but having reached the FA Cup Final in 1969, losing to Manchester City 1-0. The 1970s were to bring a similar pattern of highs and lows and four different managers.

Frank O'Farrell was appointed as the manager in December 1968, and although he was unable to prevent the club's relegation after the following season, he led Leicester City to promotion and the Division Two title before leaving in June 1971 to move to Manchester United. An additional bonus for the fans in that year was an opportunity for Leicester City, as the Division Two winners, to play the FA Cup runners-up, Liverpool, as a result of the Division One champions, Arsenal, being committed to European competition. City beat Liverpool 1-0.

Jimmy Bloomfield succeeded Frank O'Farrell, and at no time since his time with the club has Leicester City remained in the top division for so long. The club also reached the FA Cup Final in 1973/74. During his six years at Filbert Street, Bloomfield created a side of free-flowing skilful football on what was described at the time as a shoestring budget with players including Len Glover, Keith Weller and Frank Worthington. He is still regarded as one of Leicester's all-time top managers. He returned to Leyton Orient in 1977, and then coached at Luton Town before his premature death at the age of just forty-nine in 1983.

Immediately after Bloomfield's departure from Leicester, City were relegated once again at the end of the 1977/78 season. Frank McLintock, who had played for the club for several years in the 1950s and 1960s, had succeeded Bloomfield but resigned to make way for Jock Wallace to pick up the pieces and to lead Leicester to the Division Two championship in 1980.

The 1970s saw a truly world-class player come to prominence at Filbert Street. Leicester-born Gary Lineker joined the youth academy at Leicester City in 1976,

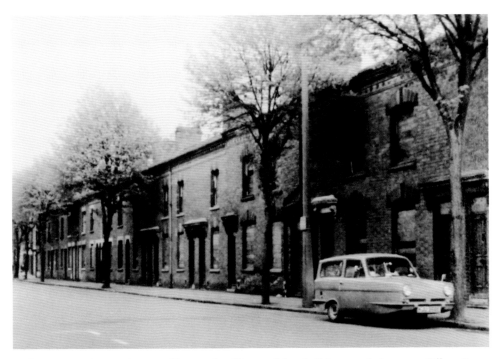

Walnut Street: A row of terraced houses familiar to all football fans on their way to Filbert Street in the 1970s. This area of Walnut Street was awaiting redevelopment in 1975.

having left school with a comment on his report card that 'he concentrates too much on football' and that he would 'never make a living at that'. His career began slowly with only occasional appearances, and he failed to score in any of the first ten games he played at Filbert Street, but gradually the star quality emerged and he was to help in City's promotion to Division One in 1980, and from there-on the stage was set for a career that brought both personal and team accolades.

Rugby

After the doldrums of the 1960s, the new decade was a time of good matches, excellent coaching and increasing attendances at Welford Road for Leicester Tigers. 'Chalkie' White had arrived in 1968. His demanding and progressive approach encouraged a new approach to tactical play and a higher standard of fitness. As a result, the quality of the game improved and more and more rugby fans came to enjoy the matches. His appointment was controversial because the amateur status of the game meant that coaching was frowned upon as tantamount to cheating. A former player, White was teaching at Nottingham High School, a post he maintained even after being hired by Leicester Tigers. He was to take the team to John Player Cup wins in 1979, 1980 and 1981, and as losing finalists in 1978 and 1983. White died in 2005. When news reached Welford Road, Dusty Hare, Tigers' Rugby Development Coordinator, who joined the club as a player in 1976, commented:

Chalkie was my mentor, without him I wouldn't have achieved what I did. His passing is a very sad moment for the club and the world of rugby.

At the start of the 1970s, Tigers had less than 700 members. The average gate at matches was less than a thousand. But by 1980, the club had reached its first cup final, and the scene was set for a period of very substantial growth. For almost all Leicester rugby fans, the highlight of the year was the annual Boxing Day game against the Barbarians which was played in front of a packed stadium.

Cricket

The relevant chapter in Leicestershire County Cricket Club's published history is titled 'Illingworth Arrives', and it is certainly the figure of Yorkshire's Ray Illingworth which would dominate the club's progress and achievements through what has been described as its 'first golden era' and is currently regarded as the county's finest decade to date.

The first major achievement of this era was the Benson & Hedges Cup, the county's first-ever trophy, in 1972, with Leicestershire's Chris Balderstone named as the man of the match. This was the first of no fewer than five trophies in five years which included Leicestershire's first County Championship title, gained on 15 September 1975. That match was also a personal triumph for Chris Balderstone. Batting on 51 against Derbyshire at Chesterfield, after close of play he then changed into his football kit to play for Doncaster Rovers against Brentwood in an evening match thirty miles away. That match ended in a 1-1 draw. Balderstone is the only player to have played League football and first class cricket on the same day. On the following morning he returned to Chesterfield to complete a century and take three wickets to clinch the title. In the same season, Leicestershire's final success was a second Benson & Hedges victory.

Speedway

Speedway and greyhound racing enthusiasts all agree that the Blackbird Road stadium, with its wide sweeping curves, was one of the best in the country, but the 1970s was to be the final decade.

Speedway had returned to Leicester Stadium in 1968 with the formation of the Leicester Lions team under Reg Fearman and Ron Wilson, their move to Leicester having been prompted by the closure of their former home, Long Eaton, to which they had moved from Leicester in 1968. During the 1970s, the team competed in the top division of British Speedway, the British League, and in 1977 Vic White took over from Ron Wilson, the pair working together as co-promoters for the remainder of the decade.

Occasionally, at this time, speedway was also staged on an indoor track at the Granby Halls, the first event being the Midland Individual Championship which was held in the halls in January 1972. It was won by the excellently named James Bond who, during his career, rode for the Wolverhampton Wolves, Swindon Robins, Long Eaton Archers and Leicester. He retired in 1974.

The last speedway meeting at Blackbird Road was held on 25 October 1983. A stock car Grand Prix was held in the following year, but then the doors were closed for the final time and after fifty-six years of sporting activity, the stadium was demolished to make way for a housing estate.

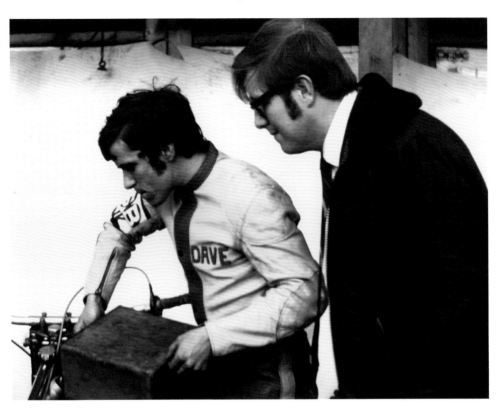

Blackbird Road Speedway, July 1974: BBC Radio reporter Mike Smith watches as a Leicester Speedway rider refuels his bike at the stadium on Parker Drive in July 1974.

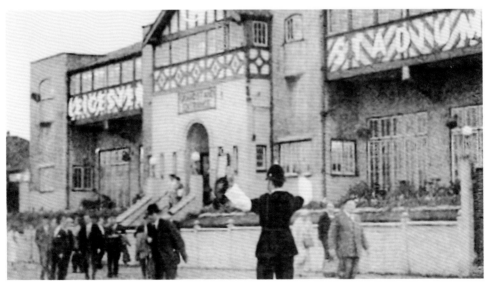

Blackbird Road Speedway: The stadium on Parker Drive in its heyday, with a policeman on point duty controlling the traffic. Built in 1923, the stadium was demolished in 1984 as part of a housing development.

Rowing

The sport of rowing moved into the city centre in 1885 as part of the annual Abbey Park Flower Show. The Leicester Rowing Club had been formed in 1882 in Belgrave and at first used part of the canal in the northern area of Leicester.

In later years, the club moved again to the 'one mile straight' in the heart of Leicester. It was not the ideal location for any water-based sporting activity. The 1970s was still flanked by many factories, mills and other industrial premises as well as the more picturesque Castle Gardens. From 1973, part of the adjacent railway land was used as a large scrap yard for dismantling redundant railway rolling stock, which caused much concern regarding the potential for further pollution of the river and canal. In fact, the only significant pollution from the site was to the ground and was a result of an arson attack in 1991.

In 1970, the Leicester Rowing Club became mixed, and the first women's crew was able to represent the city at regattas across the country.

In 1972, the Leicester power station closed down, which caused considerable changes to the ecology of the canalised River Soar in the area. The water used by the station to cool the turbines had caused problems for rowers, producing a thick fog in cold weather and creating strong currents which pushed boats across to the far bank. However, without the continuous warming effect of the outflow, the river now tended to ice over in winter which sometimes prevented rowers from taking to the water.

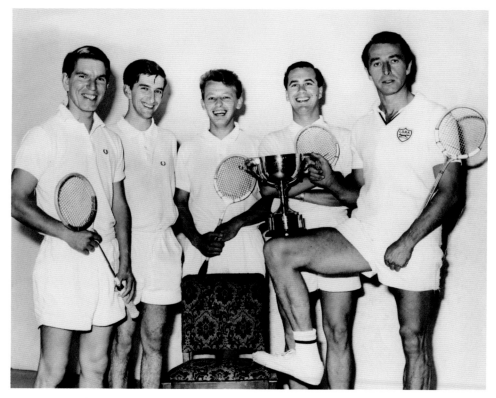

Leicester Squash Club: The popularity of squash in Leicester grew immensely in the 1970s with a number of talented players who had improved their game and skills in the previous decade. In this group (left to right) are Ian Foster, Bill Harvison, Barry Mason, Derek Hockridge and Ian Turley.

Rowing remains a popular activity in Leicester, supported by both the universities, and the latest refurbishment of the Castle Gardens area (in 2015) is enabling many more Leicester people to enjoy this aspect of the city's riverside.

Squash

The huge expansion of squash nationally centred on the decade of the 1970s. From less than a dozen courts in Leicestershire at the end of the 1960s to 167 courts in the 1980s, the extraordinary popularity of the game saw the formation of the Leicestershire League in 1974, which became the second largest competitive league in the United Kingdom.

The world's leading amateur, Leicester Squash Club-based Michael Oddy, having 'retired' in 1964, returned to the game in 1971 to become club and county champion and captaining Scotland in the same year. Ian Turley, later to become England Squash captain, created a national record by winning his fourteenth county title in 1974, having first appeared in the final in 1955. Nine-time County champion Ann Jee, later to receive an MBE for services to women's squash, began her service on the world committee which she would ultimately chair.

Leicester Squash Club reached the Banbury Cup Final for the 'best club in the UK' title. The supremacy of the club with numbers of international players was being challenged by newly built Squash Leicester and other county clubs – the standard of play in the county was among the highest in the country.

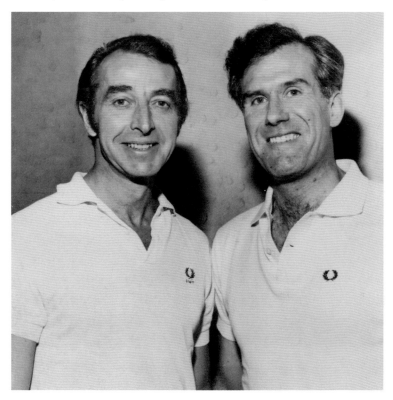

Leicester Squash Club: Two top squash players from the 1970s, Ian Turley and Mike Oddy (left and right).

Golf

The Leicestershire Golf Club expanded its Gartree Road course in the 1970s, having had to give up its clubhouse and its opening and closing holes to the newly built ring road. Its new clubhouse on Evington Lane opened at the beginning of the decade and three new holes were developed backing on to the Shady Lane Arboretum. Golf in the county also flourished.

Admiral Sportswear

A small Leicester-based textile company became the market leader during the 1970s in personalised sportswear. Admiral Sportswear had been set up in Wigston by Christopher Cook and Harold Hurst in 1908, manufacturing underwear, and created the Admiral trademark in 1914. It was not until England's success in the 1966 World Cup that they began manufacturing sportswear.

Capitalising on the advent of colour television and the heightened excitement in English football, T. H. Patrick, the then owner of the company, persuaded football clubs to accept individually personalised kits, which his designers produced and registered under the Design Copyright and Patents Act.

Admiral then manufactured and marketed football kits, appealing to young fans who wanted to emulate their football idols. Fans and, in particular, children enjoyed being able to buy and wear the same style and colour kit as their heroes and the market

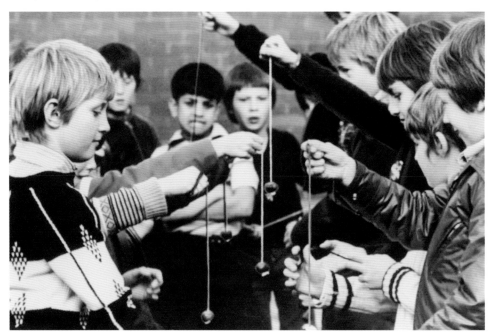

Leicestershire Inter-School's Conker Championships: The World Conker Championships began in Oundle, Northamptonshire in 1965 and prompted renewed enthusiasm for this age-old playground game. In 1977, the county championships were held at Rowley Fields School in Leicester. It is estimated that one in six schools have now banned conkers for fear of allergic reactions.

grew rapidly. The company became the original pioneers in the development of the replica kit market, supplying clubs and their fans with individually designed home and away kits featuring distinctive colours, the Admiral logo and club crests.

In the 1973/74 season, Leeds United became the first English top flight club to wear visibly branded kit with the Admiral logo positioned prominently on the shirt and shorts. The kit was also made of a new lighter material instead of the traditional cotton and, in another innovation, the socks had tags as well.

Building on the domestic market success, Admiral agreed a five-year contract with the English FA in 1974 to produce the first commercially available England shirt. The new shirt was first worn in a 3-0 victory over Czechoslovakia on 30 October 1974. The Admiral logo was positioned alongside the three lions of England, the first time any manufacture had been given such prominence.

Internationally, Admiral began to produce kits for many NASL teams in the United States during the late 1970s and agreed a replica licensing deal with all clubs, including the New York Cosmos.

3

MUSIC

With technological advances in audio equipment, all forms of music became more widely available in the 1970s and in higher quality. Gramophones had long since given way to record players capable of high-quality sound reproduction; portable VHF transistor radios similarly enabled listeners to enjoy all musical styles with a new richness of sound. In Leicester's clubs and music pubs, the new technology led to the age of disco with ever more impressive lighting effects.

It was in the immediate post-war years that music, culture and fashion began to relate to each other more closely, often with popular music reflecting changes in social attitudes. The lyrics of protest would be reflected in the way that performers dressed, and a small elite group of thinkers and writers, including Leicester's Colin Wilson, legitimised the voices of protest, although by the 1970s Wilson had moved on to studying and writing about the occult and the darker side of society.

The De Montfort Hall, thanks to its size and its ability to accommodate almost any musical genre, was undoubtedly the venue that served the most number of Leicester people, whether attending a concert by the Leicester Symphony Orchestra, performances by Leicester school children or gigs by the best-selling bands of the day. But Leicester still had an amazing variety of music enterprises, all of which were well supported and were as diverse as brass bands, church choirs and punk bands.

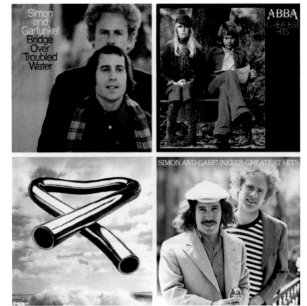

Best-selling LP albums: The four most successful popular music albums of the 1970s. Still on sale today, Abba, Simon and Garfunkel and Mike Oldfield have together sold over ninety million copies of these albums.

There was never a 'Leicester sound' to match the popular music styles emanating from Liverpool of Manchester. Leicester is a far more insular place but is a city that has produced a very reasonable number of outstanding musicians in all genres. For many of these performers, the 1970s would be the golden decade of their careers.

Popular Music

The 1970s marked the end of an era in pop music. It was when The Beatles disbanded. Each of the 'fab four' went their separate ways appearing on solo albums. Arguably the world's most famous group of all time was no more. The pop and rock music world, which The Beatles had forever changed, would never be the same. The pop music world also lost two iconic figures in tragic circumstances. On 18 September 1970, Jimi Hendrix was found dead in London. Just weeks later, on 4 October, Janis Joplin died in Hollywood. The world of peace and love and the hippy culture of the previous decade were beginning to fade.

Almost every conceivable form of 'popular' music was available in this decade of colour television and hi-fi sound, and the different strands became ever more difficult to describe. There was country and country rock. There was soft rock, southern rock, hard rock, rock and roll, arena rock and heavy metal.

On the international stage, Britain's Elton John, formerly a pub pianist in a London suburb, became a major success in the United States. The Jackson Five – with a twelve-year-old Michael Jackson – began to be noticed, Diana Ross left the Supremes and turned her back on the Motown sounds of the 1960s, and Simon and Garfunkel produced their massively influential *Bridge Over Troubled Waters*.

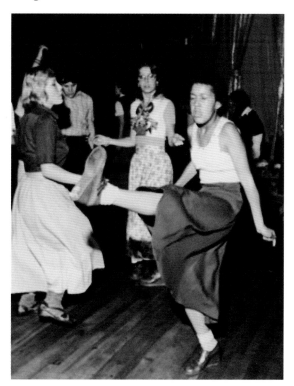

Palais de Dance, Humberstone Gate: Dancers enjoying the music of the Northern soul night at one of Leicester's most popular dance venues of the 1970s.

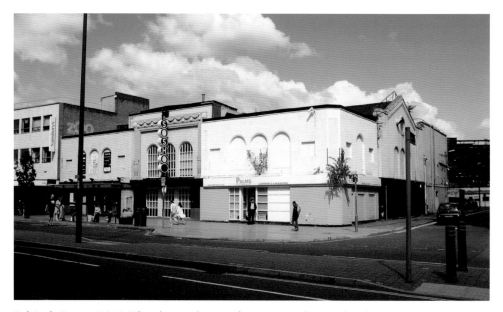

Palais de Dance, 2015: The place to be seen for so many thousands of Leicester teenagers over several decades, the heyday of the Palais was in the 1960s and 1970s. It is still a lively club venue in the twenty-first century.

In this country, it was arguably heavy metal which became the developing theme of the period with groups including Alice Cooper, Deep Purple, Led Zeppelin, Queen, Nazareth, Black Sabbath, AC/DC, Kiss, Aerosmith and Van Halen becoming very popular and gaining so-called 'super group' status.

In 1979, Paul Loasby, an experienced music promoter who was then working on the UK tour of Rainbow, formed in 1975 by Deep Purple's Ritchie Blackmore, planned a one-day festival featuring hard rock and heavy metal bands. His intention was to time the event to be the final show in the Rainbow tour. His colleague Maurice Jones knew Tom Wheatcroft, the owner of the Donington Park race track, and the site became the venue not only for this event but for annual Monsters of Rock festivals through to the 1990s.

The central location of Donington Park, with good motorway access to the M1 and to major routes to the West Midlands, enabled good transportation from around the United Kingdom. The ground also sloped, which allowed for good visibility of the stage from all areas. The first festival was held on 16 August 1980 with Judas Priest, the Scorpions, April Wine and Saxon supporting Rainbow. The event also provided another 'first': Saxon's gig was released as a 'semi-live album' with the title '*Donington – The Live Tracks*'.

Country music is one of the most enduring forms of popular music, and the recordings of many of the artists of the 1970s who combined country with other forms such as folk and rock are still popular today, including The Eagles and Emmylou Harris. The music of protest was never more vocal and insistent than in the long campaign against the Vietnam War. These actions continued unabated until America finally pulled out in April 1975.

The list of the best-selling singles of the decade features some notable local-to-Leicestershire names and several rather unusual offerings. In 1972 and 1973, Simon Park, the conductor and arranger from Kibworth in south Leicestershire, achieved

success with Eye Level, the theme to the Thames Television crime series *Van de Valk*, which starred Barry Foster. Simon Park's enigmatic and clever arrangement of a Dutch nursery rhyme outsold Leicester band Showaddywaddy's best-selling single of the decade which was Under the Moon of Love. The sugary 'Tie a Yellow Ribbon Round the Ole Oak Tree' by Dawn with Tony Orlando was a major hit in 1973, possibly reflecting the mood in the United States as Vietnam veterans began returning home.

Reflecting the popularity of heavy rock, Pink Floyd' s 'Another Brick in the Wall' sold millions of copies in 1979, and Queen (with Leicester-born bass guitarist John Deacon) achieved their greatest-ever hit with Bohemian Rhapsody which was first released on 31 October 1975 and stayed at the top of the charts for nine consecutive weeks. It reached No. 1 again after Freddie Mercury's death in 1991 at which time it became the third best-selling single in the United Kingdom of all time. More than 2.4 million copies have been sold to date, far more than its closest rival Mull of Kintyre by Paul McCartney's 'Wings' which was the top-selling single of the 1970s.

John Deacon played in his first band, The Opposition, in Leicester in 1965 at the age of fourteen. By 1970, he was studying at the Chelsea College in London where he gained a first-class honours degree. In 1971, he met the other members of Queen, attended an audition at a lecture room in Imperial College, and joined up. In 1973, a reviewer for *Rolling Stone* magazine wrote that:

> The combination of drummer Roger Taylor and bassist John Deacon is explosive, a colossal sonic volcano whose eruption makes the earth tremble.

Deacon's compositions for Queen included 'You're My Best Friend', 'I Want to Break Free' and 'Another One Bites the Dust'.

On the record: The BBC Radio Leicester Record Library photographed in August 1971. Vinyl LPs were the order of the day.

The Local Music Scene

A very considerable number of aspiring pop musicians from the Leicester area were performing at this time, each moving between different bands as they each followed their own particular musical genre.

For a brief moment in the history of Leicester's popular music scene, Family were in the ascendant. Formed in the city in the closing weeks of 1966, they stayed together until October 1973. In 1970, they played several gigs in the United States, including San Francisco and Boston, and released their most successful album, *A Song for Me,* in the same year. It was followed up with *Anyway*, later in the same year. Family gave their final concert at Leicester Polytechnic on 13 October 1973. Its members moved on to different musical projects. Roger Chapman and John 'Charlie' Whitney formed Streetwalkers. John Wetton played with King Crimson and later became the lead singer of the band *Asia*. Rob Townsend was a member of Medicine Head between 1973 and 1975 and then worked with both The Blues Band and The Manfreds.

Spring were regulars at the Il Rondo club and well known for just one album released in 1971 on the Neon record label. The band members parted company in 1972 with Pick Withers later joining Dire Straits and Ray Martinez in Showaddywaddy.

Pesky Gee had been formed in the late 1960s in the Braunstone area and managed one album and one single. The band was later to become the more well-known and successful Black Widow.

Black Widow released their debut album, *Sacrifice*, in 1970, but the band was more known for its fantasy concepts involving mock rituals and dramatics on stage. Their act gained them certain notoriety but also resulted in venues pulling the plug when they thought the band had gone too far. Later, their drummer Romeo Challenger joined Showaddywaddy.

Yet another Leicester band that released a debut album in the early 1970s was heavy rock act Gypsy. Their biography is relatively brief but reached certain high spots: They released two albums, four singles, supported Led Zeppelin on their first UK tour, performed on Top of the Pops and were banned by the BBC. Although popular at local venues, the band lost their recording contract in 1973 and broke up. Their drummer, Moth Smith, later appeared with Diesel Park West.

A very different musical talent came to Leicester in 1970. Lorenzo 'Laurel' Aitken, who had been born in Cuba in 1927 and brought up in Jamaica, moved to the city. One of the originators of Jamaican Ska music, Aitken is now widely regarded as the 'Godfather of Ska'. Ska, a precursor of reggae, first originated in Jamaica in the 1950s. It combined calypso, rhythm and blues and American jazz with a strong 'walking' bass line and with a rhythmic emphasis on the upbeat, as in some forms of syncopation.

Aitken was a frequent performer in Leicester, particularly at the Costa Brava restaurant where he worked under his real name, Lorenzo. He also recorded occasionally under the name of King Horror. He died in 2005.

The Woolworth store in Gallowtree Gate, Leicester, had been the first of that company's chain in the United Kingdom to be fitted with a 'modern' record department. For the first time Woolworth stocked a full top twenty chart of singles and albums by the real artists, along with a back catalogue of classical and instrumental music. The Decca Record Co. provided the company with the background expertise.

Classical Music in Performance

One of the most remarkable and major choral events ever to be staged in the United Kingdom took place in Leicester in 1976. The event was organised by the European Federation of Young Choirs in association with the Leicestershire Education Authority, and it brought together many hundreds of young singers from not only Europe but beyond, including Israel. Over several weeks, the choirs met, rehearsed and performed in venues across Leicestershire, but the grand culmination of their studies and practice was a memorable concert given at Leicester's De Montfort Hall. The distinguished composer Sir Michael Tippet, who had enjoyed a long association with the Leicestershire School of Music, was present for a performance of his oratorio *A Child of our Time*. The work dwells on the persecution of young Jews by the Nazis during the Second World War. Tippett had registered himself as a conscientious objector.

There were many poignant relationships in the performance, not the least being the young choirs from both Israel and Germany taking part on the stage. But also, the De Montfort Hall was the venue where Tippett as a teenager, attending Stamford Grammar School, had first been 'turned on' to music (to quote his own phrase). His music teacher had been Malcolm Sargent, later to become the familiar conductor of the Last Night of the Proms in the Albert Hall. Sargent brought a party of his students to Leicester to hear the Leicester Symphony Orchestra, which Sargent conducted at that time.

The significance and high emotions of the event were recognised by all who took part and for many in the audience. The *Leicester Mercury* music critic Ralph Pugsley sensed this, as he wrote in his subsequent review:

The stage seemed to be set for something uncommonly moving and memorable yet (it might have been the result of expectancy running too high) I felt in this performance that the height of inspiration had not quite been attained.

Europa Cantat VI had begun with an equally memorable concert, with the role of conductor shared between Tippett and Eric Pinkett, the pioneering principal Music Adviser for Leicestershire in his final year with the county. Ralph Puglsey noted:

Sir Michael's seemingly eternal youthfulness, evidenced in his looks and elegance on the rostrum.

The entire sequence of concerts and recitals attracted large audiences and gave the hundreds of young people who took part a taste of Leicester life in the 1970s:

The atmosphere there has the gaiety and uninhibitedness of a vast international night club with dancing and impromptu singing until the small hours.

1976 was also the jubilee of the Diocese of Leicester, which had been refounded in 1926, and again the Leicestershire Schools Symphony Orchestra was involved in a musical celebration at the De Montfort Hall. In the presence of Princess Alice, Duchess of Gloucester, the concert was also a celebration of the quality of local soloists including Elizabeth Cox (soprano), Michael Hardy (tenor) and Peter White (cathedral organist

and conductor of the Leicester Bach Choir). The Bishop of Leicester, the Right Revd Ronald Williams, was reportedly delighted with the event though made no comment about the music:

> The striking things about the concert were the widespread of support and the wide variety of people who were there from all parts of the city and county.

Later in the season, the same venue was selected for a farewell concert in honour of Eric Pinkett, who had led music education in Leicestershire since immediately after the Second World War. The event very deliberately demonstrated how Leicestershire's music students had progressed to national and international status. The leader of the Leicestershire Schools Symphony Orchestra on this occasion was Peter Lewis, a member of the BBC Symphony Orchestra, who had first led the county schools when it was formed in 1948. The six soloists were all ex-members of the County School of Music and were all, by the 1970s, professional musicians working mainly in London. Joan Clamp (oboe) was a member of the BBC Symphony Orchestra and James Watson (trumpet), John Price (bassoon) and Nigel Pinkett (cello) were playing with the Royal Philharmonic orchestra. Rolf Wilson (violin), former leader of the BBC Welsh Symphony Orchestra, also took part, as did David Pugsley (clarinet and recorders), who was a member of David Munrow's Early Music Consort of London. Munrow, a brilliant young musician, was a graduate of Leicester University.

Homeground radio talent: DJ Adrian Juste from Oadby, who honed his unique broadcasting skills at BBC Radio Leicester before joining BRMB in Birmingham in 1973 and then BBC Radio 1.

Music at the Granby Halls: In the space of just ten days in 1979, Blondie, The Police and The Jam all played at the Granby Halls. This *Leicester Mercury* photograph is of The Police on stage on 20 December 1979.

Brass Bands

Alongside the exploration into the new musical forms of the age of amplification, and the grand choral set pieces staged at the De Montfort Hall, Leicestershire's most traditional music forms continued to prosper. In the city and across the county, thousands of musicians ranging from children to their grandparents, and often involving entire families, played regularly in their local brass band.

Some of the bands boasted a long history which linked back to the working class movements of the nineteenth century, as was apparent in their names such as the Wigston Temperance Band. Many of the bands were village bands with local players, as in Hathern, Ratby, Croft and Enderby. Others, such as the City of Leicester Club and Institute Band, were supported by the working men's clubs, and in the county, at Desford, Snibston and Whitwick, many had their roots in the coal industry. The Snibston Colliery Band had formerly been known as the Coalville Ebenezer and, in the 1970s, became the William David Construction Group Band as different sources of sponsorship were available. The Desford Colliery Band enjoyed national acclaim at this time, and the Leicester Foresters Band also became a national rather than a local band.

Even musical hobbies became embroiled in the industrial turmoil of the period. Several of the bands that were still associated with collieries were called upon to lead marches of striking miners, and at times had to put their normal cycle of activities, such as preparing for and appearing in competitions and contests, on hold.

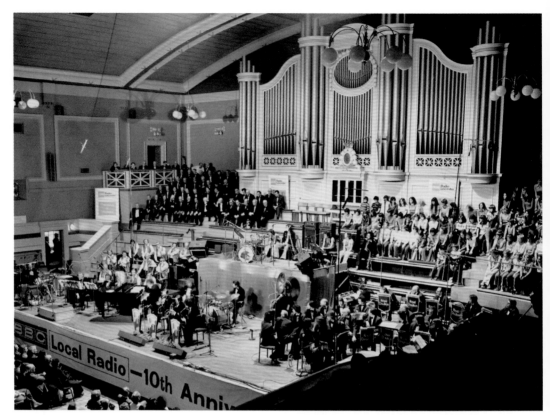

De Montfort Hall, November 1977: The large stage is packed with local and national performers for a concert to celebrate the tenth anniversary of BBC Radio Leicester.

The City of Leicester Brass Band Festival, staged on 28 November 1970, attracted bands from farther afield. The winning bands in the various categories were the Thoresby Colliery Welfare Band from Nottinghamshire, the City of Oxford Silver Band, the Rothwell Temperance Band and the Newarke Town Band.

4

ENTERTAINMENT

Professional theatre returned to Leicester in the 1970s with the construction of the Haymarket theatre as part of the large Haymarket shopping centre, which formed the largest development in the central area of the city for several decades.

The two largest cinemas, the Odeon in Queen Street and the ABC in Belgrave Gate, continued to prosper, and benefitted from a series of Hollywood blockbusters, but in the outlying districts, the smaller cinemas continued to decline.

Television was the rising star, although the BBC's Broadcasting in the Seventies Plan, introduced in the latter years of the 1960s and implemented on 4 April 1970, helped to reinvigorate radio listening. Just three days in to the decade, Open University programmes began on radio and television, and in the following month, the 'radio only' licence fee was abolished. It was now clear that the most dominant source of entertainment for most households would be the television set. For many Leicester people, a Saturday night out at the club or the local picture house was replaced by a Saturday night in front of the television set as broadcasting schedulers worked to create a compelling sequence of viewing from teatime to bed time.

The concept of entertainment, as well as news and information, being 'delivered' to your home on demand by means of the internet, was still more than a decade away. Dial-up internet services came to Leicester in 1992.

Technical Innovations

After the dramatic broadcasting innovations of the previous decade, including colour television, the BBC continued to develop new forms of communication. The BBC had experimented with stereo transmissions for a number of years, at one stage using a radio transmission to provide one sound channel and the BBC1 transmissions to provide the other. Initially, the BBC had seen stereo as a transitory gimmick, but it became heavily involved in its development in the 1970s when it was extended to all the corporation's networks with the audio quality of frequency-modulated (FM) transmissions.

In 1974, the BBC launched its first on-screen text information service. Ceefax provided news and information which could be selected by viewers using a remote control. It was arguably the first 'on demand' broadcasting system, giving licence fee payers an element of choice in the type of news and information they wished to read, and when they wished to read it. A further step in the democratising of broadcasting came with the introduction of phone-in programmes, allowing the listener to be engaged and involved actively with a live programme and, to a limited extent, to influence the course of a discussion.

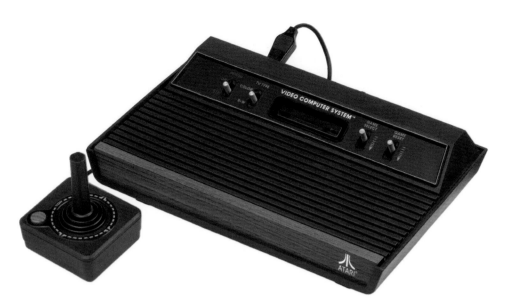

Atari 2600: Released in October 1977 as the 'Video Computer System' this became one of the most successful consoles in history.

Microcomputers were marketed in the first years of the 1970s, but the 'personal computer', or PC, was not designed until the 1980s. The giant IBM Co. created the PC as it is known now, but the early companies working during the 1970s included Olivetti and Hewlett Packard. Arguably, the technical calculator manufactured by Hewlett Packard in 1968 and throughout the following decade was the first machine to be based around a microprocessor. But in the practical world, computers were still largely science fiction and the domain of television programmes such as *Thunderbirds*.

Clubs

Despite competition from television, the 1970s was the heyday of social clubs. At the beginning of the decade, there were over 4,000 establishments affiliated to the Working Men's Club and Institute Union (CIU or C&IU) in the United Kingdom with more than six million members paying a subscription fee. Thousands of entertainers, professional and semi-professional, found employment by travelling widely across the country and often appeared alongside talented local amateurs.

Many clubs began spending large amounts of money on upgrading their facilities, and as a result these venues attracted much local support and were often full to capacity at weekends. BBC Radio Leicester, well aware of the vibrancy of the local club scene, broadcast a weekly list of acts and attractions, compiled by the local CIU secretary Tommy Carton. These ranged from entertainers of national recognition to the unusual local acts which possibly had their roots in the music hall of the past.

The popularity of social clubs, particularly in the Midlands and the north of England, led to Granada Television launching *The Comedians* in 1971. The programme was recorded before a live audience in Manchester and featured many of the top comedians of the club scene, such as Russ Abbot, Lennie Bennett, Stan Boardman, Jim Bowen, Duggie Brown, Colin Compton, Ken Goodwin, Roy Walker and Tom O'Connor.

The acts included a significant number of jokes of a racist and sexist nature which, in a decade that had not encountered the term 'politically correct', did not offend the majority of the audience. It was a world of 'working men', where women were still prohibited from joining some organisations.

A similar attempt by television companies to challenge the popularity of the clubs was the *Wheeltappers and Shunters Club*, hosted by comedians Colin Compton and Bernard Manning. Thirty-eight episodes were broadcast between 1974 and 1977.

Television

Competition between the BBC and the independent television companies led to a decade of new and often innovative programmes, many of them worthy of being described as 'cuttingedge'. Drama series which are still regarded as some of the finest programmes ever produced by the BBC included *Elizabeth R*, *The Six Wives of Henry VIII*, *I Claudius*, *Pennies from Heaven*, *Last of the Summer Wine*, *The Glittering Prizes* and *Tinker, Tailor, Soldier, Spy*.

New BBC television comedy series ranged from the slapstick *Are You Being Served?* (1973) and *It Ain't Half Hot Mum* to the ground-breaking *The Fall and Rise of Reginald Perrin* (1976), *Not the Nine O'Clock News* (1979), *Fawlty Towers* (1975) and, undoubtedly, the irreverent and anarchic *Monty Python's Flying Circus*. This was also the decade which brought *The Two Ronnies* (1971), *Porridge* (1974), *Rising Damp* and *The Good Life* to our screens. The largest television audience for any comedy show was attained by the *Morecambe and Wise Christmas Show* in 1973 ,which attracted 25 million viewers.

Mastermind, *The Generation Game*, *That's Life*, *The Antiques Roadshow*, *Young Musician of the Year*, *Top Gear*, *One Man and His Dog* and *Question Time* all began during the 1970s. Award-winning documentaries included Jacob Bronowski's *The Ascent of Man*, Sir David Attenborough's *Life on Earth* and Alistair Cooke's *America*.

The commercial television companies pitched in with a similarly diverse range of programming headed by *Coronation Street,* which remained at the top of the audience ratings throughout the decade. *Emmerdale* was launched on 16 October 1972, and the *Benny Hill Show* led the listings of the most popular comedy show, the comedian's risqué humour being very much a reflection of the social attitudes to sex of the time. *Mind Your Language*, starring Barry Evans as young teacher Jeremy Brown, began in 1978, as did *The Professionals*. Other ITV programmes of the decade included *Doctor in the House, Sapphire and Steel, Father, Dear Father, Rumpole of the Bailey* and *On the Buses*.

Possibly the first popular television drama series to raise ethical questions about pollution, the environment and sustainable industrial growth was *Doomwatch*. The series was developed by two writers, Gerry Davis and Kit Pedler, who had introduced Cybermen to *Dr Who*. They created a government agency led by Dr Spencer Quist, played by John Paul, which investigated and prevented catastrophes caused by industrial pollution and unrestricted experimentation. The series was launched on 9 February 1970. One episode, which involved actual news footage, was never screened as it was deemed to be too shocking. Greenpeace was formed in October 1970 (as the 'Don't Make A Wave Committee') and constituted as 'Greenpeace' in 1972, but its principles and concerns were not known to the wider public.

Local Radio

BBC Radio Leicester entered the 1970s with some assurance about its future. Along with seven other small stations, it had been launched as an experiment. There had been doubts about its future funding and its effect on the profitability of local newspapers, but in 1970 the BBC confirmed that their fledgling local radio network was to be expanded. Maurice Ennals, the manager who had set up BBC Radio Leicester, relocated to the south to launch BBC Radio Solent, and his departure was followed by many other members of the original staff, moving not only to other BBC stations but also, as in the case of Adrian Juste, to commercial radio.

With its future confirmed, BBC Radio Leicester expanded its staff and set up its own newsroom, with its first news editor on the ninth floor of Epic House in Charles Street, the floor above its studios and offices. Many of the first journalists moved from print journalism, but the newsgathering and writing processes were similar and still based on typewriters, telephones and telex machines.

In the 1970s, local radio stations such as Radio Leicester began to influence their national counterparts in terms of operating and production techniques. The pirate radio stations had always operated at minimal cost, and BBC local radio was certainly a very inexpensive form of radio broadcasting. During the decade, more programmes became 'self-operated' in which the presenter controlled his or her own sound equipment and played their own records or tapes. More use was made of portable recording equipment which allowed individuals to record complete programmes

BBC Radio Leicester: *Conkers* was an innovative BBC Radio Leicester programme in the 1970s for young Leicester listeners. Here, the presenter Greg Ainger is with children on the steps of Brookfield House on London Road, Stoneygate, which was then the Charles Frears School of Nursing.

without the assistance of engineers. The so-called 'built' programmes, pre-recorded in advance, gradually gave way to longer live 'sequence' programmes which were more economical and more flexible in responding to breaking news stories and including 'listener content' such as phone-ins.

Although still having to operate under considerable financial restraints, it was a successful period in the station's history as it expanded its output, developed new programmes including the 'phone-in', became less dependent on the rebroadcasting of the BBC's national networks and linked itself with many aspects of the city's life. Its technical equipment was basic but had been well built and was therefore reliable, and the staff were well trained and supported by a training unit based in London.

This confidence was exemplified in its impressive Tenth Anniversary Concert in November 1977 which was held at the De Montfort Hall and involved celebrity guests and performers whose success had been fostered by BBC local stations. Every seat was taken, and, remarkably, almost all the tickets had to be booked and collected in person from the small reception on the eighth floor of Epic House.

During the early years of the decade, the BBC opened a further nineteen local stations, but completion of the network was halted by the government to enable commercial radio stations to gain a foothold. The last of this new group of stations to be launched was Leicester's nearest neighbour, BBC Radio Derby. The new emphasis on a stronger news output was underlined when the station opened before its planned launch date in 1971 from a temporary studio at the Sutton Coldfield VHF transmitter in the West Midlands in order to cover the financial crash of Rolls-Royce. The first of the 'independent' stations opened in the largest centres of population. It was the first time in its history that BBC Radio faced competition, with London Broadcasting (LBC) and Capital Radio opening in London in 1973. It was not until 1981 that Leicester would have its own commercial station, Centre Radio, based at Granville House in Granville Road, opposite Victoria Park.

National Radio

Until 1970, the BBC had been the only radio broadcaster in the United Kingdom, with the possible exception of Manx Radio on the Isle of Man. Its only competition had come from Radio Luxembourg and, in the 1960s, the pirate radio stations transmitting from vessels anchored just outside UK territorial waters. It was a service which revelled in its heritage, which dated back to the 1920s. The Home Service, although having produced many cutting-edge comedy shows such as *The Goon Show* and the war-time *ITMA*, was formal, serious and 'wholesome', providing a carefully compiled diet of news, information, education and religion. The Light Programme, transmitted from the powerful long wave transmitter at Droitwich in the West Midlands, provided light entertainment and a variety of musical forms including jazz and big band, while the *Third Programme* and its occasional offshoot, *Network Three*, served listeners who wished for classical music and intellectual debate.

Still funded by the Foreign Office, the BBC's World and External Services provided a service which was respected and trusted throughout the world from its grandiose base at Bush House in the Aldwych. Announcements in over fifty different languages were still accompanied with a short performance (played from 78 rpm gramophone records) of stirring marches including 'Imperial Echoes', 'Lilibulero' and Eric Coates' 'Calling All Workers'.

Given the BBC's near monopoly of transmitters and its strong respect for its own heritage and history, the Broadcasting in the Seventies Plan was a remarkable shift in corporate attitude. The corporation's founding father, John Reith, whose dour paternal convictions had dominated the BBC long after he had resigned as Director General in 1938, died in 1971. Reith is still the longest serving Director General, but his severance from the BBC had been a complete one: he very rarely listened to any of the services he had helped to create and never watched television.

The government had long been critical – and envious – of the BBC's independence, and its ability to spend more money, year on year. It was not unanimous in its support for the corporation's plans, as Paul Bryan MP indicated in a speech to Parliament in 1969:

> When we examine the BBC's new proposals, we wonder whether it appreciates its own achievements, for it appears to be tending to throw them away lightly. The axe seems to be falling almost exclusively on the educational and cultural services appealing to minorities which a commercial broadcasting system is unlikely to supply. If this blueprint materialises, we shall be left with little more than a facade of public service broadcasting. Radio One is to be all Caroline. Radio Two is to be all sweet music, or 390. Radio Three is mostly serious music, but […] in reality it has been cut by being limited to VHF. It would not be available in motor cars. The audience would be decimated. It will be cut to a great extent by this new restriction. Radio Four is largely a speech programme. Therefore, catering for minorities has been reduced to the truncated Radio Three and some talks and drama on Radio Four. The policy of trying to improve public taste has been quietly but completely abandoned.

In September 1972, the BBC began stereo transmissions on 45 per cent of programmes on Radio 2. The event was marked in October of that year by a special 'stereo week' highlighting the improved sound programmes. London and the south coast were covered first, with coverage extended to the whole of the United Kingdom two years later. The many popular broadcasters on Radio 2 included Jimmy Young, Terry Wogan, Pete Murray (with his *Open House*), Tony Brandon and Simon Bates. Comedy on the same network included Roy Castle's *Castles on the Air*, the long-running *News Huddlines* with Roy Hudd and a new radio soap opera, *Waggoner's Walk*.

In many Leicestershire schools, children would still listen to the BBC's schools broadcasting service. The most established and popular offerings for their parents included *Women's Hour*, *Morning Story* and *Afternoon Theatre*, all programmes which are still familiar to many radio listeners today.

Cinema

In Leicester, as in most large towns and cities, the 1970s would be the last decade in which the large auditorium city centre cinemas still held sway. Because of the competition from television, many of the smaller neighbourhood picture houses had closed. In April 1970, the Evington was sold to a new management for use as an Asian cinema screening Bollywood films, but it closed in 1978. The Fosse on the corner of Fosse Road North and Pool Road struggled until the early 1980s.

So it was mainly to the Odeon in Queen Street and the ABC in Belgrave Gate that cinema audiences of the earlier years of the 1970s would flock to see the latest Hollywood blockbusters. The Odeon's large auditorium seated 2,182 but was divided

ABC Cinema, Belgrave Gate: The plush interior of this large city-centre cinema, designed in art-deco style, opened in 1937 as the Savoy. It was demolished in 1997. (*Leicester Mercury*)

into three screens in 1974. The ABC was formerly The Savoy, having been renamed in 1960. It was divided into two screens in 1970, with just over 600 seats in the former circle as one 'screen' and 910 seats in the former stalls as the main screen.

Although Hollywood faced a string of financial crises at the beginning of the decade because of a series of films that flopped at the box office, many of the most popular films of the twentieth century were released during the 1970s.

The 1960s had seen the release of a number of anti-war films responding to the social mood of that time, but the emphasis changed in the next decade with films that showed, sometimes in graphic detail, the reality of armed conflict. *Patten: Lust for Glory*, starring George C. Scott, and *MASH*, directed by Robert Altman, were both major box office draws in 1970.

James Bond was alive and well throughout the decade, first in the shape of Sean Connery, in *Diamonds are Forever*, and then as portrayed by Roger Moore in *Live and Let Die*, *The Man with the Golden Gun*, *The Spy Who Loved Me* and finally one of the most successful Bond films of all time, *Moonraker*, released in 1979.

Disaster films included *The Poseidon Adventure* in 1972 and *Towering Inferno*. Gritty drama was represented with *The French Connection* and *The Godfather*, but the most ground-breaking of all was the controversial Stanley Kubrick film, *A Clockwork Orange*.

Theatre

A major city centre development of the first years of the 1970s was the Haymarket Centre occupying a triangle of land enclosed by Belgrave Gate (leading to Haymarket), Charles Street and Humberstone Gate. Within that development, which was principally devoted to shops, was constructed the Haymarket Theatre. It replaced the old Victorian theatres which had been demolished some years earlier and in fact was located directly opposite the site of the former Palace Theatre on Belgrave Gate.

It had taken several years to commission, design and finance the Haymarket development. In the interim, theatre audiences had been served well by the small but dynamic Phoenix Theatre as well as the amateur-led Little Theatre in Dover Street.

The Haymarket Theatre opened in 1973. The official ceremony was presided over by Sir Ralph Richardson. The building was designed by Stephen George and Dick Bryant from the city council's Architect's Department, who had also designed the Phoenix. It was both an attractive and unusual building which, in many of its design features, was far ahead of its time.

From its first season, the Haymarket Theatre attracted men and women of great imagination and skill. In its first season, local theatregoers were able to see *The Recruiting Officer*, the classic comedy play from 1706 by the Irish writer George Farquhar, *Economic Necessity*, a new play in 1973 by John Hopkins, and starring Anthony Bate, and the musical *Cabaret*.

Two of the theatre's first production directors were Robin Midgeley and Michael Bogdanov, and for many years Robert Mandell was the musical director, masterminding a string of immensely successful musicals, many of which later moved to London and even to Broadway. These included *Joseph and the Amazing Technicolour Dreamcoat*; *The Boyfriend*, which included the late Miriam Karlin and a young Elaine Page in the cast; *Oliver*, starring Roy Hudd as Fagin; *My Fair Lady*, and *Oklahoma*. Born in New York, Mandell had worked under Leonard Bernstein and moved to London in 1972 as the musical director for the Anthony Newley and Leslie Bricusse musical *The Good Old Bad Old Days*, which ran for 309 performances at the Prince of Wales Theatre. His flamboyant style and personality brought vigour and enthusiasm to the new theatre in Leicester.

The De Montfort Hall

As in previous decades, and despite the construction of the Haymarket Theatre, the De Montfort Hall, located a significant distance from the city centre, remained the mainstay of broad-stream entertainment for many thousands of Leicester's residents.

Its auditorium had changed little from local architect Shirley Harrison's original design as it appeared when the hall opened in 1913, with just over 3,500 seats and a vast stage which could accommodate a large orchestra and choirs. The stage itself could seat more people than the main auditorium of the Haymarket Theatre. The grand concert organ dominated visually, and was used for concerts and performances by local choirs and orchestras, but had been neglected and rarely tuned. But the De Montfort Hall was, and remains, a part of life for the majority of people in the city and further afield, providing a remarkable variety of entertainments, from classical orchestras and gigs by the top pop groups of the decade to religious and civic events.

Arguably, the De Montfort Hall has been the most relevant municipal public building and entertainment provision in the city in the past century, but in the 1970s, it began to suffer from a lack of investment. As a point of comparison, Nottingham City Council completed the refurbishment of the Nottingham Theatre Royal in 1978 at a cost of £4 million. In the same year, Leicester City Council agreed to give the De Montfort Hall a new coat of paint. The Taylor concert organ, a gift to the city of Sir Alfred Corah, was allowed to fall into an almost unplayable condition, the Council unwilling or unable to provide funding for repairs for a further twenty years. It was – and is – an important cultural asset: in its present near-pristine condition it is said to be worth an estimated £5 million.

New Bridge Street, 1975: A view along New Bridge Street from the former Joseph Street towards Infirmary Square, with extensions to the Leicester Royal Infirmary under construction. The hospital now covers this entire area.

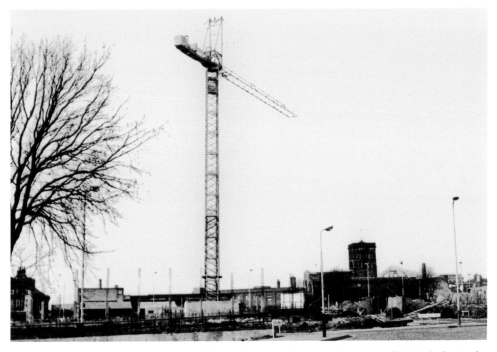

Holiday Inn: Under construction in 1970, with the ancient parish church of St Nicholas in the background. The road already bears the modern name of 'St Nicholas Circle'.

The Urban Landscape

Post-war development in Leicester had focussed on providing new homes in the suburbs and in clearing the remaining slums in the inner city. It was not until the later years of the 1960s that the central shopping area began to change significantly and dramatically.

Much of the new development was driven by the increased ownership of motor cars, which had led to frequent traffic jams at key junctions in the city centre and around the clock tower. This was not an altogether new problem: Charles Street had been constructed in 1932 in order to relieve the High Street, Haymarket and Gallowtree Gate areas of traffic. However, an unsympathetic attitude to the city's building heritage, the 'reverence' with which the motor car was viewed, the popularity of precast concrete as a building material and the brutalist designs of the time all combined to change the urban landscape in an uneven and disruptive way.

Changing social trends also added to the mix. The concept of shopping centres with integral car-parking led to the construction of the Haymarket shopping centre and the

Flooding at Braunstone Lane East: An almost annual problem in Leicester in the 1970s, by which time this road had become a heavily used access route to the M1. This photograph dates to 1979. The road still floods because any solution would be at a prohibitively high cost. (*Leicester Mercury*)

demolition of a number of important buildings. The expansion of supermarket chains meant not only the gradual removal of small independent shops to the outskirts and neighbourhoods but also the decline of the traditional city-centre department stores including Morgan Squire, Marshall & Snelgrove (Adderleys) and the Co-op.

A fairly rare and unforeseen occurrence in 1976 led to subtle changes in the urban landscape and in day-to-day life. The very dry winter of 1975 was followed by one of the driest and hottest summers on record, leading to one of the most famous droughts in the history of the United Kingdom. The very severe shortage of water in reservoirs led to various forms of rationing including a ban on cleaning buildings and vehicles, swimming pools and using hosepipes and sprinklers. Standpipes in streets were used in Yorkshire, East Anglia and areas of Leicester including Groby Road. Levels at Thornton reservoir in the county fell to such a low level that Severn Trent Water shutdown its filtration systems.

The government appointed Denis Howell as 'drought minister' and he prescribed a range of homespun solutions such as placing bricks in toilet cisterns and sharing a bath. George Newton, the Soar divisional controller for the Leicester Water Centre ,appeared on television to appeal to viewers to reduce their water consumption as much as possible, commenting that if rain did not fall soon, then many people would face hardship and, potentially, there could be a loss of jobs and income. The drought finally broke in late August, with the first drops of rain being felt in the mid-evening just after dark.

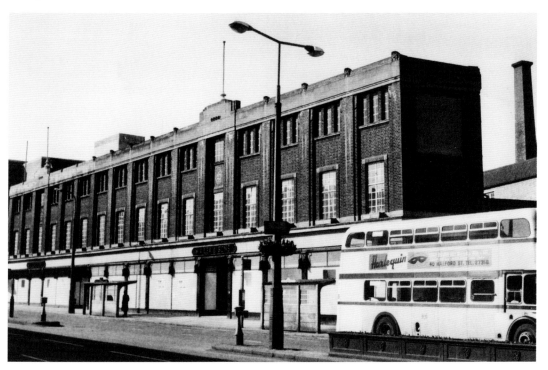

W. A. Leas & Sons: Leas' extensive store was constructed by Everard Son & Pick in 1876 and extended in 1910, 1934 and 1955. C&A occupied this location when the Haymarket Centre was built. After their demise, Allders moved in until they went into administration in 2005 when Primark took over this prime site.

W. A.Leas & Sons: The grand entrance and clock is a statement of the pride and longstanding reputation of this family business. This view during demolition of the corner of Humberstone Gate and Charles Street dates to 1970.

New Buildings

In 1975, Leicester City Council bought the New Walk Centre at the cost to ratepayers of £5 million. The building had been a speculative project and had remained empty since its completion some years previously. The acquisition was controversial. The Leicester Mercury reported that, in a poll, 97 per cent of Leicester people who had offered a view were opposed to the purchase, mainly because of the cost to local government following a time of recession and high inflation.

Jack Simmons, then Professor of History at the University of Leicester, disliked the buildings – one of eight storeys and the other of thirteen storeys – because of their scale and dominance over the neighbouring streets and landscape. In a television interview for ITV, Professor Simmons even predicted its. He commented:

> Most of the concrete stuff that they are putting up in Leicester is exceedingly ugly and will get very tatty very quickly. I'm afraid the twenty-first century is going to think very ill of us indeed in what we are doing in that way now.

The building was demolished, by controlled explosions, in 2015, after surveys had shown that it had become structurally unsafe.

Haymarket Theatre: Leicester's justifiably renowned Haymarket Theatre imaginatively incorporated into a shopping centre. This view is from the entrance steps off the Haymarket, exactly opposite the site of the former Palace Theatre.

The Victorian developers made Leicester into a redbrick town and arguably changed the character of the town as dramatically as any construction of the twentieth century. But the concrete towers, which were built in the 1960s and 1970s, were of a texture and a scale that could not work in sympathy with the surrounding structures. These included St George's Tower at the southern end of Charles Street overlooking St George's Way and London Road. With twenty storeys, it has a height of 82 m. The nearby Cardinal Telephone Exchange on Humberstone Gate is 84 m in height. Both were constructed by British Telecom (BT) in the pre-digital era when large buildings were required to accommodate bulky switchgear.

Leicester on Fire and Under Seige

In June 1974, over one hundred patients, some seriously ill, had to be evacuated from the Leicester Royal Infirmary due to a major fire. In all, fourteen fire appliances were needed to fight the fire, and one patient had to be rescued from a smoke-filled area through a second-floor window using a turntable ladder. Ironically, it was the Health and Safety at Work Act of that same year which required that all staff in establishments such as hospitals should have fire safety training.

Towards the end of the decade, in August 1979, a dramatic fire at the Pecks Factory near West Bridge could be seen from most areas of the city. The building

had been constructed in 1844 as a worsted spinning mill owned by Whitmore's, a local manufacturer. It was acquired by Pecks at the beginning of the First World War. Sixteen appliances were used to prevent the fire, which had taken hold of one building, from spreading through interconnecting bridges to the main six-storey building. Two firemen narrowly avoided serious injury when part of an end gable wall collapsed.

Both buildings were saved, and there were no injuries or loss of life. The Pecks building survived to be converted in 1982 into riverside apartments.

On 1 September 1975, four Leicester people died in a quiet street in West Knighton. The Lamborne Road siege followed an acrimonius divorce settlement in which Sabi Nikoloff was forced to give up his house. On that day, he returned to his former home, and on seeing a former neighbour who had given evidence against him in court, collected a shotgun from his lodgings and returned, shooting Enid Cabaniuk dead at point-blank range and also shooting at another friend of his ex-wife who was on the opposite side of the street. He then went into the house and set fire to the stairs while his ex-wife and their younger son Bruno screamed for help from an upstairs window.

When the emergency services arrived, Nikoloff shot at three police officers. Sgt Brian Dawson was killed; PC Margaret Dayman was seriously injured. An ambulance driver, Terry Wilkinson, who attempted to manoeuvre his vehicle between Nikoloff in order to give assistance to the police officers was also shot dead. Nikoloff was jailed for life on 10 February 1976.

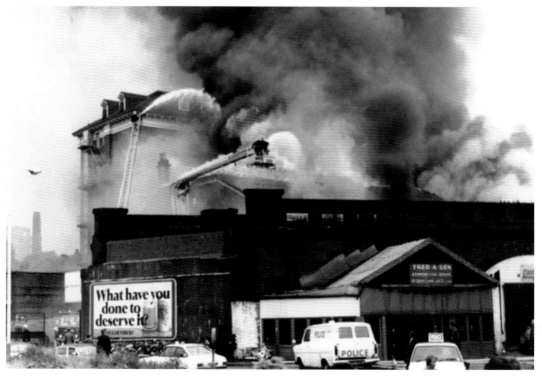

Pex factory fire, 1979: Firemen tackling the major blaze at the Pex factory on Leicester's riverside in August 1979. The message on the advertising hoarding is strangely ironic. (*Leicester Mercury*)

East Midlands Airport

In 1970, the runway and terminal at East Midlands Airport at Castle Donington were extended and a new freight complex was constructed. The development marked a change in the economic fortunes of the airport, which had struggled financially in the late 1960s. The airport was formerly an RAF station, decommissioned in 1946. The site was purchased by a consortium of local government authorities in 1964 and a programme of building work and runway investment commenced. It opened for passenger traffic in 1965.

Although the transport of freight was the major activity at the airport, due to its location near to the M1 and links to the West Midlands via the A42, M42 and M6, the package holiday trade of the 1960s had been a further stimulus to its growth and expansion. It was the nearest gateway for Leicester people to the sun-drenched beaches of the Costa de Sol, Crete and the Algarve. The runway was extended again in the late 1970s to 2,283 m (7,490 feet), and the terminal buildings were again refurbished.

However, although cheap package holidays, which included transfers from the destination airport and resort accommodation, had flourished in the late 1960s, they declined in the following decade. In 1974, the industry was disrupted by the collapse of Court Line, then the second largest tour operator. Nearly 50,000 tourists were stranded overseas and a further 100,000 faced the loss of booking deposits.

Leicester Co-operative Society, High Street: The modernising of Gallowtree Gate in the 1960s left High Street a rather quiet and neglected area in the 1970s, but the Co-op on the corner of Union Street, with its many departments and floor levels, remained a popular destination for shoppers, and for some time fought off the challenge of the new supermarkets. It was designed by Thomas Hind as the centre store and offices of the Leicester Co-operative Society and opened on 10 November 1894.

Leicester Co-operative Society, High Street: The dignified exterior of the Leicester Co-op, designed by Thomas Hind and opened on 10 November 1894, has survived to the present day as part of the Highcross shopping centre.

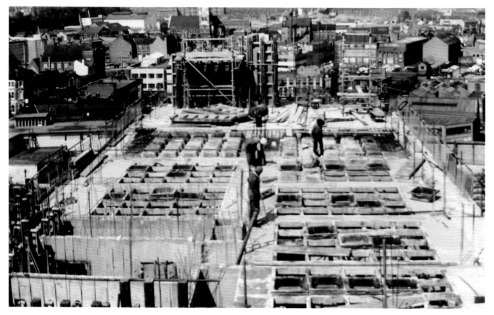

Crown House, Lower Hill Street: The construction of Crown House looking east, with the spire of St Mark's in the background, photographed in July 1972.

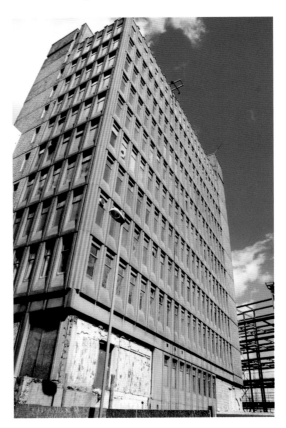

Crown House 2015: New buildings are being constructed adjacent to Crown House on the line of the former Lee Street, but Crown House itself is now unoccupied and decaying.

City Centre Planning

The construction of new roads in Leicester and the management of the increased traffic in the city centre in the 1970s were largely based on the policies of the previous decade. The brutal carving out of the Central Ring as part of the Smigielski plan greatly damaged the heritage and underlying archaeology of Leicester, and forced a pedestrianisation scheme upon the central area.

'Old' Leicester was based on the town as laid out by the Roman planners and militia nearly 2,000 years ago. It was designed on a grid principle of intersecting roads and insulae, and in the twentieth century many of these ancient road intersections were still in existence. The curving route of the Central Ring ignored this underlying structure, cutting through historic boundaries, denigrating old and traditional intersections and the buildings that overlooked them. The historic north–south highway of Highcross Street between the Northgate and the Southgate was reduced to an insignificant lane, and on its continuation as Southgate Street uneasy compromises were made at places such as the ancient but significant Newarke Gateway, more familiarly known as the Magazine Gateway, which found itself totally marooned between several lanes of fast traffic travelling in opposing directions.

The Central Ring also diverted attention from the old and quaint streets in the area west of the clock tower, now referred to as the 'old town' in the vicinity of Guildhall Lane, Silver Street and Southgate. The buildings in this quarter, which were mainly Victorian, but with some dating back to medieval times, were neglected. In retrospect,

St Nicholas Place: This building, derelict in the 1970s, on the corner of Guildhall Lane and Highcross Street is now the Clockwise Credit Union. To the left was the former Wathes store, which is now the studios of BBC Radio Leicester.

perhaps this neglect actually protected them for the future, as these lanes and their grimy buildings were not recognised as having any development potential. The overall result was that development was centred on the spine of Gallowtree Gate; the quiet and often delightful lanes adjacent remained unnoticed and largely untouched.

The planners of the 1970s were not to be held to blame totally for the confused road planning that characterised the decade and later years. The notorious Central Ring had been on the drawing board since the 1930s, and Smigielski's plan of the 1960s was modified and, arguably, sanitised to a point where it failed to meet all criteria, by the city planners of the time. Even today, in the twenty-first century, the buildings at the centre of the Holiday Inn roundabout appear to be half-finished.

A newcomer to Leicester in the early years of the decade saw a city that was rebuilding and redesigning itself, at least in the square mile to the east of the old town. The idea of enclosed pedestrian walkways across Charles Street and Humberstone Gate from the new Haymarket Centre suggested modernity, but beyond that small area, and Gallowtree Gate, little was changing. The appearance of Granby Street, Halford Street, Rutland Street, Belvoir Street and Town Hall Square remained the same, dominated by the red-brick buildings of the Victorian era.

The view from the roof of one of Leicester's sky scrapers, such as St George's Tower, would tell a different story. From this elevated perspective, looking south, the history of the city's town planning was illustrated in changing colours. Close by, the red-brick and grey slate dominance of the past. Further afield, the light grey expanses of the modern housing estates such as St Matthews based on concrete, even further on, a return to the red-brick suburbs of the Highfields area, and on the horizon the futuristic towers of Leicester University.

Belgrave Flyover: Taken from the top of the newly constructed flyover in 1976, this image shows children playing in the fountain and the Wolsey building in the background. (Leicester Mercury).

Belgrave Flyover: The flyover was never used as a dual-carriageway, but the funding that was secured for its construction required that it should be built to accommodate two lanes.

Wyvern Hotel: This impressive building was designed by local architect Arthur Wakerley and opened as a temperance hotel next to the London Road railway station. It was never truly successful and closed in 1933. The building was used by Shell-Mex-BP and later as the offices of British Road Services. It was demolished in 1974 and replaced by Elizabeth House.

Public Transport

The 'new' British railway operation of the 1970s was very different from the straggling and out-of-date system of the early 1960s. The last steam locomotives had been scrapped, replaced by diesel, diesel-electric and electric power units. Stations and entire branch lines had been closed under the Beeching Plan, and the emphasis was on creating a fast, reliable service between major cities and population areas.

Electrification of all the main lines in the country was the ultimate goal, but one which has still to be realised more than forty years later. Consequently, railway engineers began work on designing a train which would provide fast, comfortable rail travel using diesel-electric traction as a stop-gap measure. Two different projects were inaugurated, the High Speed Train (HST) based largely on existing technology and the Advanced Passenger Train (APT) or 'tilting train' which was intended to use cutting-edge research into the interaction between wheels and track.

The HST was brought into service on the Western Region in 1976 but was not introduced on the Midland Mainline, serving Leicester, until the early 1980s. The design has been immensely successful. It still holds the world record speed for diesel traction of 148.4 mph, and the units, although having been refurbished and modernised, are still in daily operation in 2015, transporting thousands of passengers from Leicester to London St Pancras and to Sheffield every day.

Catherine Street Bridge: This multi-arched bridge took Catherine Street over the former Great Northern railway line, which ran parallel to Cobden Street and the Willowbrook. This *Leicester Mercury* photograph was taken in 1973 just before its demolition.

The APT experience was very different. A small number of units were built and brought into operation, but technical failures and a media-fuelled belief that the tilting systems made some passengers feel disorientated and sick led ultimately to the abandonment of the project. Even on its first-ever journey, in July 1971, the fact that it was operated by a single driver led to a one-day strike by ASLEF, the rail union, which cost British Rail more than its entire research budget for a year.

However, the technical advances that the APT project made in traction engineering were used ultimately in the Italian State Railway's Pendolino trains which entered service in 1987 and operate on a number of routes in the United Kingdom.

Faster train services required a more reliable signalling and train management system, and in 1973 British Rail purchased the Canadian computer-based Total Operations Processing System. Possibly the only visual evidence of this new system to passengers and trainspotters was the renumbering of every locomotive.

The 1970s were the last decade in which Leicester City Transport and Midland Red, with their familiar liveries, would operate in the city and suburbs. The 1985 Transport Act, introduced by Margaret Thatcher's government, would see bus services deregulated, and municipally owned operations transferred to private companies. Initially, Leicester Citybus Ltd was set up with Leicester City Council holding almost 94 per cent of the shares, the others being owned by Trent Motor Traction. The company, with its fleet of 217 vehicles, was then sold to GRT Holdings in November 1993.

The Advanced Passenger Train: Intended as the future for fast and comfortable rail travel in Britain, the prototype APTE visited London Road railway station in 1973. It was never to go into service.

Rutland Street, LCT bus depot: Leicester City Transport's Rutland Street depot photographed at the end of 1979.

Rutland Street, LCB Depot, 2015: From a building of the nineteenth-century textile industry to a state-of-the-art traffic management location in the 1970s, LCB – totally rebuilt again – is now a thriving art and business community.

Shops, Markets and Supermarkets

Although self-service stores had existed since the 1950s, it was in the 1970s that the shopping experience in Leicester changed forever. At the beginning of the decade, one of Leicester's most famous traditional retail names closed its doors. Exactly ten years after *Carry On* star Sid James opened Tesco's first supermarket outside London, beneath the Lee Circle car park, Simpkin & James' head branch in Horsefair Street closed in 1971. Simpkin & James was then the oldest grocer in Leicester, having been trading since 1862. Significantly, the company's profits had been increasing steadily, year on year, since the end of rationing in 1954, until 1965, by which time the supermarkets were beginning to exert a real impact on shopping trends.

By the time that Simpkin & James had vanished from the city centre, the three major supermarket chains were well established. In addition to the Lee Circle Tesco store, Sainsbury's traded from Humberstone Gate and also Evington Road, and Safeway was operating from Charles Street. Each was employing new approaches to marketing including reward schemes in the form of trading stamps, Green Shield stamps at Tesco until 1977 and the rival S&H Pink Stamps at Sainsbury's.

Setting a different trend, Waitrose also moved into the area but not in the city centre. In September 1970, the company opened a store in Ethel Road on the Goodwood Estate, which traded for forty years until it was replaced by the present store in Oadby. Tesco was later to follow the trend of securing larger retail space in developing areas where land was more available and less expensive, moving its Lee Circle operation to Beaumont Leys. Another arrival in Leicester was the Comet discount chain selling white goods and home hi-fi equipment. The company became a publicly listed business in 1972.

Left: Simpkin & James: One of Leicester's oldest and respected retail names, Simpkin & James in Horsefair Street closed in 1970. The company had been founded in 1804.

Below: Simpkin & James: Shoppers pounce on bargains at the final sale at Simpkin & James' in Horsefair Street before it closed.

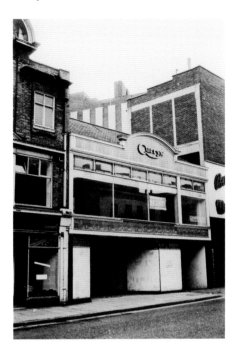

Curry's, Belgrave Gate, 1970: The Curry's retail
chain was founded in Belgrave Gate, Leicester.
This was the founder Henry Curry's second store,
located in the Haymarket near the clock tower,
boarded up and awaiting demolition.

There were two other notable names in the Leicester of the 1970s. Woolco, an
American company owned by the more familiar F. W. Woolworth, had opened its
large self-service store in Oadby in 1967. With a very wide range of goods and ample
parking space, it proved very successful and led to further stores across the United
Kingdom. The company also refurbished its store in Gallowtree Gate to demonstrate
to the city's planners that its commitment to city centre shopping would remain.

Also in the city, on Belgrave Gate, Northampton entrepreneur Frank Brierley was
competing with the big players with his unique style of discount marketing. He became
a millionaire overnight when, in 1970, his chain was floated on the stock exchange; but
just four years later he was convicted of fraud and served a prison sentence of six months.

Products and Prices

Supermarkets had been part of the shopping experience for some years and were by no
means a new innovation in the 1970s. They developed and began to set up exclusive
contracts with manufacturers and suppliers which were to provide a major increase in
the choice of food and other lines available, including the concept of the 'own brand',
advertised as being as good in quality as the recognised brands but less expensive. The
corner shop felt the competition immediately, finding it a challenge to compete on
either choice or price, and therefore sought to survive on customer loyalty and their
convenient location, perhaps the forerunner of today's so-called 'convenience stores'.
After decimalisation, many shoppers found it more difficult to compare the unfamiliar
prices such as working out whether 9.5p for a loaf of bread was more or less than they
had paid previously when they had been charged in the region of 1s 10d. Many felt
that the change to decimal currency masked price rises. This was no doubt the case
because of the underlying inflation, but whether the conversion drove up inflation or
allowed retailers to increase their profit margins is still a matter for debate.

Humberstone Gate Shops, 1970: This is the north side of Humberstone Gate. The clock tower is on the left of the photograph.

Bell Hotel, Humberstone Gate, 1970: Leicester's famous hostelry established in about 1700 and regarded as the major hotel in the city and county was demolished to make way for the Haymarket Theatre development. This photograph shows the building already empty and boarded up.

All the prices in the shops and supermarkets must be considered in respect of the average take-home pay – which of course varied widely – but some interesting comparisons can be made. A pint of ordinary beer in 1971 (11p) cost just 5p more than a pint of milk (6p), although the latter was also delivered to your doorstep. It is interesting that a nourishing (and healthier) bunch of bananas would cost in the region of 18p, much more than a pint of bitter at your local. A gallon of petrol cost, on average in 1971, 33p. Beyond domestic provisions, a ticket to the Cup Final at Wembley in 1971 cost just £2. In 2015, the comparative price was £111. Similarly, the substantial increase in tobacco duties has increased the cost of a packet of twenty cigarettes from 27*d* to an average across brands of £7.

The traders on Leicester market, almost a special race of people, have seen many changes to their lives, not the least being the shortage of money and goods during the Second World War. While the supermarkets were introducing electric calculating tills which could indicate prices in both decimal and predecimal prices, in the market, fruit and vegetables continued for some time to be priced per bag, or per pound (weight), and often the cost was converted to decimal by the vendor, much to the consternation of market officials and weights and measures staff.

Over-the-counter medicines began to be found in shops other than the traditional chemists such as Boots and Timothy Whites. For the first time, customers could, if they wanted to, 'shop around' for the best prices. In time the competition would prompt these chemist chains not only to merge but also to broaden their own range of goods. These two familiar names in Leicester's Gallowtree Gate and nationwide had actually merged in 1968. Prescription charges, which had been abolished in 1965 and been reintroduced in 1968, were to remain in place.

There remained the few very traditional crafts and traders who were not affected by the many changes in trends. Tucked away in Leicester's back streets were traditional boot and shoe repairers, watch smiths and other more specialised crafts. Although fewer people now needed to 'make-do-and-mend', and a society willing to buy disposable goods was developing, there was still a demand for the man or woman with particular skills, especially in a city where its previous prosperity had been due to its skilled workforce.

Leicester Market: A Leicester institution that has witnessed many events and survived many challenges over many centuries. Leicester Market was still thriving in the 1970s.

Leicester Indoor Market: A *Leicester Mercury* photograph taken on the opening of the indoor market in 1975. Despite the modernist style – or maybe because of it – the building aged quickly and failed to meet the standards expected of modern retail structures. It survived just forty years.

Leicester Indoor Market: Another view of indoor market. The open plan design meant smell from the fish market permeated the entire building including the management offices above.

Wholesale Market, Halford Street: Leicester's wholesale fruit and vegetable market located between Yeoman Street and Wigston Street. Alongside the Ford Transits of the time is a Morris Traveller, a Bedford Utilibrake and a horse-drawn trap.

Politics and Industry

The 1970s was a decade of political drama and industrial discontent which affected every citizen in Leicester and in the country and resulted in five changes of government and four different prime ministers at four general elections. Governments struggling with high and rising inflation introduced pay restraint which led to industrial action, notably by the miners but also, by the end of the decade, many different groups of public service workers. In 1971, the introduction of decimal coinage was arguably an inflationary action which certainly masked the steady rise in retail prices of many basic commodities; but decimalisation also brought the United Kingdom a further step nearer Europe, and we joined the EEC in 1973.

In Leicester, the inherited prosperity of the 1960s with relatively high employment and a general sense of well-being led many people, perhaps, to be detached from the growing unrest in the coalfields and power stations and the increasing political turmoil in London. Leicester, for most people, was a comfortable place in which to live and work, and have a family.

In 1972, Leicester ranked as the fourteenth largest city in the country with a population of about 285,000 which had remained relatively stable for the previous

AA Townpoint Shop, Charles Street: As more families acquired motor cars, the Automobile Association invested in retail premises in city centres, as in Leicester in the 1970s.

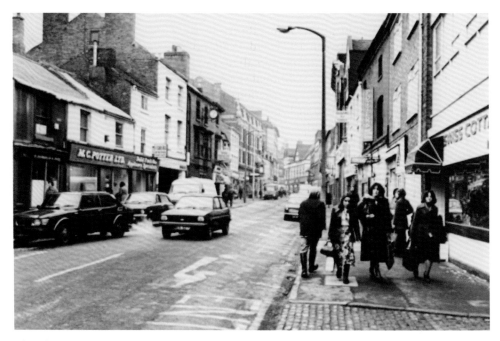

Churchgate, 1979: Despite being surrounded by modern development, this part of Churchgate near to the clock tower has retained much of its earlier character. (*Leicester Mercury*)

twenty years. At the beginning of the decade, the city boasted the least unemployment in the country. Of the 205,000 people employed in Leicester, 40 per cent were engaged in engineering, hosiery, knitwear and allied trades. The major employers were those who manufactured 'outerwear' such as Corah, based at St Margaret's works in Belgrave Gate. The next most important sections of industry, in terms of employees, were footwear machinery, hosiery, already mentioned above, and construction, followed by knitting machinery, fabric manufacture and machine tools. It was a picture similar to preceding decades, but it was not to last.

The rosy glow of prosperity would soon be replaced by a growing feeling of cynicism and a loss of faith in politicians of all the major parties. Soon after the start of the decade, the lights were to go out in the city, the refuse was to be left uncollected in heaps on pavements and the value of the 'pound in your pocket' was to diminish steadily.

The Local Political Scene

At every post-war general election in the United Kingdom, including the four elections in the 1970s, the national turnout was more than 70 per cent, compared with an average of 60 per cent for all elections since 2001. This statistic was reflected in Leicester, although the three parliamentary seats in the changed little during this decade of national political change, with the exception of Leicester South which was gained by Tom Boardman for the Conservatives in February 1974, but returned to Labour with Jim Marshall being elected eight months later. Tom Bradley held Leicester East for Labour, and in Leicester North-West Barnett Janner was created a life peer in June 1970.

However, the national political instability was certainly reflected in the local elections in Leicester. Between 1971 and 1979, political power in the city council changed hands three times, switching to Labour in 1972, to Conservative in 1976 and back again to Labour in 1979. Traditional views about class, coupled with the sharply rising influence of the non-white population, were the dominant factors. Less than 4 per cent of the city's population in 1966 were from the new Commonwealth countries. By 1971, this figure had doubled, and by the end of the decade had risen to over 15 per cent.

The Labour Party in Leicester had a strong trade union element and focused its activities on the expanding provision of municipal services, whereas the shopkeepers and small businessmen who made up the core of the Conservative group sought to limit public services in order to address rising taxation and inflation.

The growing strength of the immigrant population attracted the campaigning attentions of the National Front, which had been founded in 1967. In May 1974, it became involved in the notorious Imperial Typewriters dispute. Over 1000 Asian workers went on strike at the Imperial Typewriters factory in East Park Road in the city. Their grievances related to longstanding issues including lack of opportunities for promotion for Asian workers, bad working conditions, alleged racial discrimination and unpaid bonuses, but their action was triggered by the sacking of forty Ugandan women employees, apparently without cause or notice but related to the bonus scheme which, it was later confirmed, the company had mismanaged for over a year by withholding payments from some of the employees.

The striking workers sought the support of the local Transport and General Workers Union branch, but were rebuffed, having been informed that the management had a right to hire and fire as they wished. The company was a TGWU closed shop, and the Asian workers felt that the local union leaders were as complicit in their treatment as the management. There was no black or Asian representation on the union committee within the factory. The TGWU believed that the Asian workers were 'rocking the industrial relations boat' by not following the appropriate protocol regarding industrial relations and were refusing to follow the instructions of union negotiators, but the strikers believed that the TGWU was actively opposing their struggle for better conditions.

The decision of the Asian workforce to strike had been influenced by recent similar events in nearby Loughborough. In October 1972, 500 workers in Mansfield Hosiery Mills in the town had taken industrial action because the Asian workforce had, it was alleged, been denied access to the best-paid jobs on knitting machines. The National Union of Hosiery and Knitwear Workers had failed to support them in their attempts over many years to gain promotion. The union finally declared the strike, which lasted twelve weeks. However, the reason why the strike was successful was seen to be the strong support of local political groups, community organisations and Asian workers from other factories.

The National Front rallied support from the white employees of Imperial Typewriters, giving voice to their claim that they were losing income and employment because the company was employing low-paid Asian migrants in their place. The factory, owned by the American giant Litton Industries, closed in 1975. One year after its closure at the local elections in Leicester, the National Front won almost 20 per cent of the vote. Today, the former Imperial Typewriters premises are home to a large number of small Asian businesses.

Industry and Manufacture

In December 1974, in an adjournment debate in Parliament, Jim Marshall, MP Leicester South, spoke of the growing concern in Leicester that cheap foreign imports were destroying local jobs. He listed significant losses at several of the city's largest manufacturers, notably in machine tools and textiles:

> There is a serious situation in the city which becomes more serious week by week. In the past two or three years 2600 jobs have been lost in the city. Stibbe recently made redundant 900 men. Cotton recently made redundant 1320 men. The Wildt Mellor Bromley Group has made redundant sizeable numbers of men. We are told on good authority that before the end of the year a further 147 men will be made redundant by the Wildt Mellor Bromley Group at its Aylestone Road factory. This indicates the serious situation which not only the city but the textile knitting machine manufacturers are facing.

One of the specific causes of the downturn was, ironically, the very fast expansion of the textile manufacturing industry locally in previous years. There had been extremely rapid growth in world trade for circular knitting machines during the 1960s from £20 million in the 1960s to nearly £200 million by 1972. Leicester-based companies had gained recognition worldwide as the technological leaders in this industry. In the peak year of 1972, exports totalled £43.3 million, equivalent to almost a quarter of world trade. It was then that a saturation point was reached. In 1974, the United Kingdom's exports to the rest of the world fell by almost a quarter, and there was a sharp decline in the world market for double jersey circular knitting machines.

Charles Street roadworks: Roadworks on the corner of Charles Street and Humberstone Gate associated with the construction of the Haymarket Centre, photographed in July 1972.

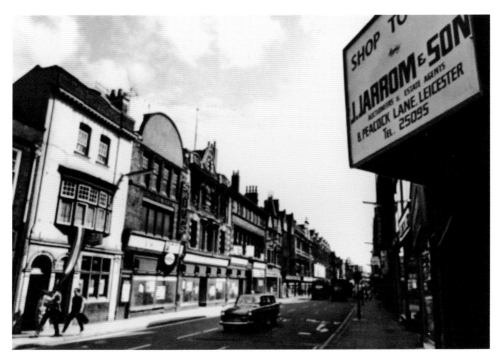

High Street: A view towards East Gates taken in 1970. The regeneration of the city's shopping centre focused on Gallowtree Gate, and Humberstone Gate leaving the high street as a retail backwater in the following decades.

At the start of the 1970s, Corah was the largest knitwear manufacturer in Europe. Its trade with Marks & Spencer was worth £20 million per annum. The fiftieth anniversary of the long and close relationship between the two companies was celebrated in 1976. But by the 1980s, years of inflationary pay rises, and the foreign competition, led to the company having to borrow in order to finance reinvestment in new machinery and techniques. In 1989, it was sold to the Australian Chartwell Group and was broken up shortly afterwards when that company suffered a huge financial crash.

The 1972 Miners' Strike

The first national strike by Britain's miners for almost fifty years was called after wage negotiations between the National Union of Mineworkers (NUM) and the National Coal Board broke down in the opening months of the decade. It was to be the opening chapter in a story of bitterness, disruption and hardship. At its annual conference in 1970, the NUM called for a £22 weekly minimum wage for underground workers. Although Leicestershire's miners were among those that paraded with banners outside the NC's London headquarters, they were hesitant to support calls for national industrial action. At one stage, prior to the 1972 strike, the Leicester area had only 37 per cent support for a strike.

Joe Gormley became the NUM President in 1971 and warned that coal stocks in Britain had fallen substantially, by more than five million tons over the past year. As 75 per cent of the electricity consumer in the United Kingdom was generated by coal-burning power stations, on 9 February 1972 the government declared a state of

Left: Miners' strike, 1972: The 1972 miners' strike also saw supportive industrial action elsewhere, as at Leicester power station, which was to close down later the same year.

Below: Miners' strike, 1972: Food parcels being offered to striking miners and their families in Thringstone in 1972.

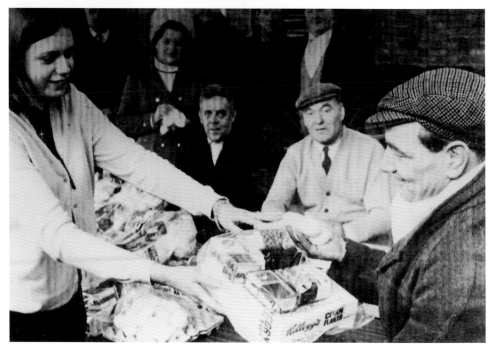

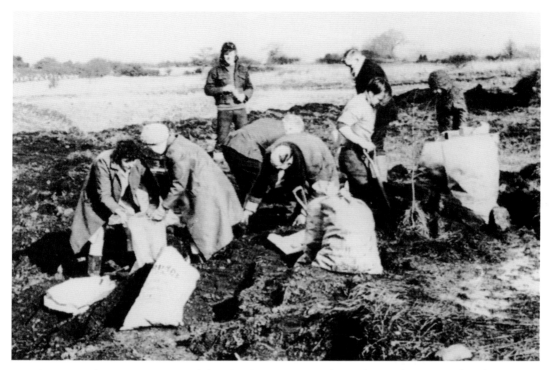

Miners' strike, 1972: Miners and their families scavenging for coal in south Leicestershire during the strike of 1972.

A power cut in Wigston: Two candles can be seen lighting a living room in Wigston during the power cuts which were introduced during the miners' strike to conserve coal stocks at power stations. (*Leicester Mercury*)

emergency and introduced a three-day working week and programmed power cuts to conserve the diminishing stocks of coal.

The disparity between wages in the mining industry and elsewhere was brought into sharp focus in Leicester and Leicestershire where local industries, such as hosiery, boot and shoes, and precision rubber manufacturing were booming. The young daughters of miners not infrequently brought home higher wages than the family's menfolk working in the pits.

Some statistics from the period have survived to demonstrate the immediate effect of the strike on local businesses and industry. Output from the biscuit manufacturer Meredith & Drew, was reduced by 40 per cent. At the Ibstock Brick & Tile Co., the drop was 60 per cent. At Bagworth, a mining settlement, Precision Rubbers laid off fifty workers.

In most towns and cities, the electricity supply to specific areas was cut for a predetermined number of hours. BBC Radio Leicester maintained transmissions by using a generator at the transmitter located on Anstey Lane, and by using car batteries to power studio equipment, playing music from portable tape recorders instead of turntables. A new evening programme was created for the period of the crisis called *Tranny by Candlelight*.

As disruption to the public grew, so too did the level of violence at pits and other locations. Violence broke out in several places, and secondary picketing fuelled the tension. The miners in Leicestershire were given no strike pay, and as a consequence they suffered considerably during the action. The Leicester and Coalville Co-operative societies sold food at a reduced price to the NUM for distribution, and the Squire de Lisle allowed miners free access to his land at Thringstone to collect firewood.

Miners' strike, 1972: Striking miners on picket duty outside the main gates of Snibston Colliery in Coalville in 1972.

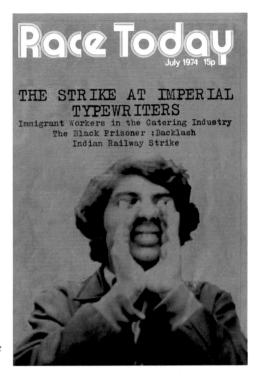

Imperial typewriters strike, 1974: The industrial dispute at Imperial Typewriters in Leicester reached the national headlines within the labour and trade union movements. This is the front cover of the Race Today newsletter for July 1974.

In the week before the strike ended, and ironically at precisely the same time that recommendations leading to the end of the industrial action were being set out, three Bagworth strikers were arrested for stealing wooden railway sleepers worth £16 from the Ibstock brick and tile works to cut up for fuel. The strike, which lasted seven weeks, ended when the miners accepted a pay offer on 19 February 1972. The union leaders celebrated their success and planned for the future. Joe Whelan, the left-wing General Secretary of the Nottinghamshire miners, noted just what the industrial action had revealed:

> How much Britain was dependent upon coal and dependent upon miners [...] because in the short period of five to six weeks we had not only the Government tottering, we had them declaring a State of Emergency, power cuts were the order of the day and industry was coming to a halt.

In less than two years, the uneasy industrial peace was to be broken again.

1974 – The Three Day Week

In Leicester, as in towns and cities across Britain, 1974 began in deep economic gloom with power cuts and a restricted working week for most of the manufacturing industry.

Throughout the 1960s, the UK inflation rate had rarely peaked above 5 per cent, but in 1970 reached over 10 per cent and from early 1971 rose steadily to over 26 per cent. The Conservative government responded by capping public sector pay rises and publicly promoting a clear capped level to the private sector. This caused unrest among

trade unions as the gap between wages and prices began to widen, leading first to a work-to-rule by British miners and finally to an all-out strike.

With coal stocks at power stations dwindling, and a reluctance to increase the import of foreign coal because of the damaging effect this would have on the country's balance of trade deficit, the government under Prime Minister Edward Heath called for a three-day week in order to reduce electricity consumption. The measure was announced on 13 December 1973 and took effect from midnight on New Year's Eve.

The commercial use of electricity was limited to three consecutive days each week. Working longer hours on those three days was prohibited. Certain essential services were exempt including hospitals, the printing of newspapers and supermarkets. Television companies were required to close down each night at 10.30 p.m.

In the bleak days of late January 1974, over 80 per cent of the NUM membership voted for strike action, rejecting a 16.5 per cent pay rise. In response, Edward Heath called a general election under the banner slogan 'Who Governs Britain?' while the three-day week was still in force. The election took place on 28 February and resulted in the Conservative Party losing its majority despite having the largest share of the vote. Harold Wilson returned to power, heading a minority government. The electorate showed disapproval with both the main parties, with a swing from the Conservatives and Labour to the Liberal Party under the leadership of Jeremy Thorpe.

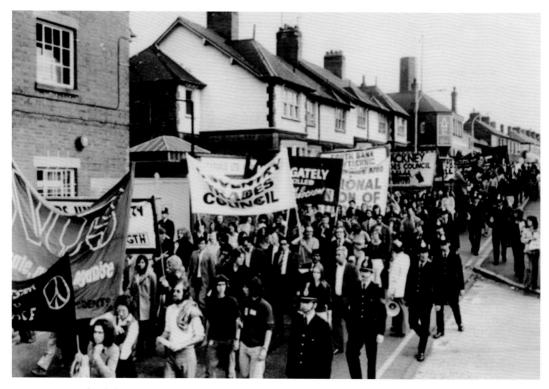

Interracial solidarity march: The bitter dispute at Imperial Typewriters attracted the attention of the National Front who announced a march through Leicester on 12 August 1974. The trade unions groups making up Leicester's interracial solidarity group staged a counter demonstration on the same day but on a different route. This photograph was taken in the Highfields area.

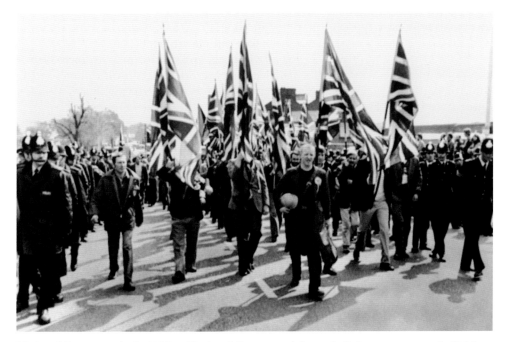

National Front march: In 1979, a National Front march brought Leicester to a standstill. More than 5,000 police officers were drafted in. Fierce confrontations led to twenty-five officers and fourteen other people being injured.

The new Labour government immediately increased the miners' wages by 35 per cent, and the normal working week was restored on 8 March, although restrictions on the use of electricity remained in force. Harold Wilson went to the country again in October, gaining a majority of three seats. In February 1975, the miners were given a further increase of 35 per cent without industrial action taking place.

1979 – The Winter of Discontent

The decade was to end as it had begun, with industrial disputes and political turmoil. During the winter of 1978/79, widespread strike action was taken by public sector trade unions reacting to the pay-capping strategy of the Labour government under James Callaghan. It was also the coldest winter for sixteen years with deep snow and blizzards leading to disruption to some public services and a reduction in spending. The unions saw the government's decision to limit public sector pay rises to below 5 per cent as reneging on the so-called 'Social Contract' that had maintained an uneasy truce for several years.

The industrial action was widespread. Refuse collections were suspended in most areas of the country, gravediggers went on strike in Liverpool and Tameside, and NHS workers blocked hospital entrances with picket lines.

On 28 March 1979, although most of the industrial action had ceased, Margaret Thatcher, as leader of the opposition, won a vote of 'no confidence' in the prime minister, forcing him to call an early general election, and on 4 May 1979, Mrs Thatcher came to power. James Callaghan was the first prime minister since Ramsay MacDonald in 1924 to be forced into an election by the chamber. He resigned as leader of the Labour Party in the following year.

Middle-East Oil Crises

In 1973, six days after Egypt and Syria launched a surprise military attack against Israel in an attempt to take back land which those countries had lost during the Six-Day War in June 1967, the United States supplied Israel with arms and military equipment. In retaliation, OAPEC the Organisation of Arab Petroleum Exporting Countries announced an oil embargo against Canada, Japan, the Netherland, the United States and the United Kingdom.

Having significant oil reserves of its own, the United States was not as affected by the embargo as the United Kingdom but chose to play up the crisis by introducing rationing and limiting traffic speeds on the interstate highways. The political fallout overall was complex, both on the domestic and international fronts, and long lasting, as were the economic consequences. OAPEC's action sent a clear signal to the industrialised world that its members could, and would, exert a very powerful influence on industries and manufacturing which, since the invention of the internal combustion engine, had assumed that oil was always going to available and relatively inexpensive.

For motorists in Leicester, it meant re-evaluating the factors which needed to be considered in choosing a new vehicle. Within a matter of a few years, the medium-sized saloon was selling in more quantities, and the 'hatchback', almost unheard of in the 1960s, gained immense popularity because of its flexible use of space and its smaller more economic engines.

A further oil crisis occurred in 1979 in the wake of the Iranian Revolution. Again, although there was no shortage of oil, panic-buying forced up the price of crude oil and caused queues at petrol stations. It triggered a period of recession in the United States. In the United Kingdom, motorists realised that the cost of motoring was never going to return to its pre-1970 level. It also led to an awareness that almost every item in every Leicester shop included within its price the cost of transporting raw material to its point of manufacture or harvest, and the distribution of the product to shop counter.

Sir Peter Soulsby: Peter Soulsby was first elected to Leicester City Council in 1974 when he was twenty-four years old. His enthusiasm for history and heritage seemingly connects with the 'establishment', but his political stance in the 1970s and, later, his links with Leicester's Unitarians, indicate his more radical views and his support for the reforming side of Leicester's political life. He became Leicester's first elected mayor in 2011 and was re-elected in 2015.

The European Union

The traditional New Year revelries took place in Leicester's Town Hall Square at midnight on 1st January 1973, but it is unlikely that many of the participants saw any relevance to their lives and to the social and economic fabric of their city in a torchlight procession taking place at the same time in Brussels. It was at that moment that the United Kingdom, along with Ireland and Denmark, joined the European Economic Community.

It was Britain's third attempt to join with Europe, the French President of the time Charles de Gaulle having opposed applications in 1963 and 1967. De Gaulle claimed that he doubted the United Kingdom's 'political will', but it is thought that he was concerned that English might become the common language of Europe and he feared also that through the United Kingdom's membership, the United States would gain an economic and political foothold.

The Prime Minister, Edward Heath, spoke optimistically but with a note of caution about new prosperity for the country:

> It is going to be a gradual development and obviously things are not going to happen overnight. But from the point of view of our everyday lives we will find there is a great cross-fertilisation of knowledge and information, not only in business but in every other sphere. And this will enable us to be more efficient and more competitive in gaining more markets not only in Europe but in the rest of the world.

The Queen's Silver Jubilee: Many street parties and parades were held in Leicester in 1977 to celebrate the Queen's Silver Jubilee. This *Leicester Mercury* photograph is of one such pageant in the Northfields area of the city

Epic House, Charles Street:
The 'home' of BBC Radio
Leicester, on the eighth and
ninth floors, with Wades
furniture store (successor
to Safeway) on the ground
floor. During the 1970s, the
radio station also broadcast
on 358 m medium wave,
as the window signage
indicates.

The leaders of Leicester's manufacturing industries were more aware of the significant changes to their markets that this historic event would bring. The city's largest employer, the British United Shoe Machinery Co., already exported to many countries but was facing growing foreign competition both from within Europe, notably Germany and Italy, and from the United States, Korea and Taiwan. It is clear that many of the city's manufacturers had been too reliant for too long on the home market, for their properity and indeed on the greatly increased demand for footwear and clothing brought about by the Second World War.

The new association with Europe was to unsettle many of Leicester's historic trading links with the Commonwealth and the rest of the world. It would also herald a revival in international cultural and political activity in the form of 'town twinning'.

SOCIETY AND CULTURE

Despite the industrial unrest and economic instability of the time, many families in the 1970s enjoyed a comfortable and relatively prosperous lifestyle. Although certain luxuries such as central heating were still not widespread, most households were acquiring a range of 'must have' accessories and had the spending power to do so. Towards the end of the decade, despite bouts of high inflation, children and teenagers had enough spending power to, for instance, buy *Star Wars* merchandise to enable the manufacturers to net many hundreds of millions of pounds.

Arguably this was a decade when quality of life was equated more with the acquisition of material comforts than on a consideration of one's health and psychological well-being. In 1974, more than a quarter of men in the United Kingdom smoked more than twenty cigarettes a day, but the figure was exactly half as many for women.

It was a decade of anomaly. It was undeniably bleak on the picket lines in the depths of winter, and many strikers suffered very real hardships. A study of the press

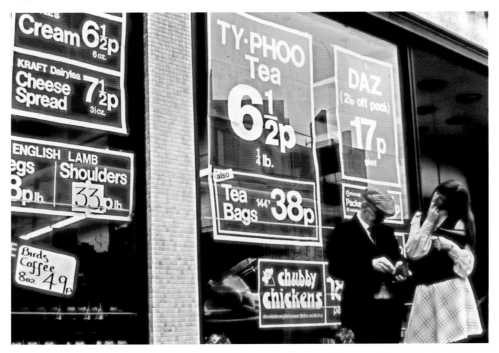

Epic House, Charles Street: Wilkinsons now occupies this retail location. In 1973, the Safeway supermarket's window posters provide interesting price comparisons less than two years after decimalisation.

Jessops' sale: In the 1970s, amateur and professional photographers from across the country would travel to Leicester for the famous annual sale at Jessops on Southgate Street near to the Newarke Street junction. Queues for the opening-day bargains were a familiar sight.

photographs of the period shows that most of the workers appeared well dressed in the fashion styles of the time. Union leaders appearing on platforms and in the media spotlight looked more like businessmen than representatives of the working class.

In April 1974, services including education, museums and libraries were combined somewhat uneasily under single directorates based at County Hall. In terms of education, the two systems were not directly compatible, having developed along different political and historic lines. Leicestershire's education provision, particularly in adult and community education, playgroups and sports facilities, was regarded as more liberal and forward-looking. Its county music service was seen as one of the finest in the country. Leicester, in comparison, although having moved towards the comprehensive system, had held on to its famous grammar schools and the traditions of the past.

Home Life

The home was (as of course it should be) a comfort and safety zone for families in the 1970s, but perhaps more insulated and protected from the turbulence of the world outside than at other times. It was a decade when, after the free-thinking social upheaval of the 'swinging sixties', family life was valued and marriage was still popular. Young people setting up home for the first time were more likely to rent than to buy outright, but they could afford to create a comfortable home, a cocoon perhaps to protect them from the harsh realities of economic life in the real world.

The average salary for a working man in the United Kingdom in 1971 was about £2,000 per annum. The average house cost about £5,500. By 1975, even in a relatively low-price housing area such as Leicester, a new three-bedroomed semi-detached house built by the Leicester-based Jelson Ltd was selling at over £7,500. Yet although many

more families lived in rented accommodation than in the twenty-first century, most homes on new housing estates around the city of Leicester were sold before they were completed, and by the end of the decade, partly due to the willingness of building societies to provide mortgages with low initial deposits, the housing boom took off. An indication of the sense of affluence was that most of these new homes were built with drives to accommodate the family car.

It is a significant fact that those who remember the 1970s – as parents or as children – although being able to recall the power cuts and three-day working weeks, and the phenomenon of constantly-rising prices as inflation soared to nearly 30 per cent, have a remarkably pleasing and strong affection for the period. They remember the crazes such as spacehoppers, and the popular television cartoons including *Bagpuss*. They are now amused by the interior design of the time, the unusual choice of coloured wallpaper, G-plan furniture and patterned carpets, all of which could be summed up in few words such as 'loud' and 'lurid'; and many still believe they looked 'cool' in the fashions of the decade, the flares and those hair styles.

Somehow, the lifestyle benefits of living in the 1970s still outweighed the underlying social and economic problems. In 1971, four million British people went abroad for their holiday. Ten years later, that figure had more than tripled to thirteen million. It was a far cry from the traditional annual Leicester Industrial Fortnight and the queues outside the Great Northern railway station waiting for the train to Skegness.

Leicester people, in keeping with those across the United Kingdom, were broadening their horizons and expectations. Many came to be more familiar with the sunny delights of Malaga and Majorca, rather than the wind and rain of Skegness and Ingoldmells. Yet broad thinking did not yet prompt a rethinking of age-old social attitudes. Numerous television programmes were undeniably racist and sexist. *Love thy Neighbour* and *On the Buses* are popular examples as are the comedy programmes reflecting the culture of the clubs. Even hinting that you enjoyed 'gay' styles such as flaunted on television by the likes of David Bowie and Marc Bolan could result in serious playground discrimination.

In 1971, women were still banned from entering a Wimpy Bar on their own after midnight. It was believed that the only females who would be wandering around at that time of night would be prostitutes. As Dominic Sandbrook pointed out in his series on the 1970s for BBC television, just eight years after the lifting of that rule, a woman walked into 10 Downing Street as Britain's first-ever female prime minister. The 1970s were certainly years of amazing social change, all viewed from the safety of your wall-to-wall carpeted lounge, on your new colour television set.

Decimalisation

On 15 February 1971, the United Kingdom adopted decimal currency. The concept had been discussed for more than a century but the final decision to go ahead was only approved by Parliament in May 1969. There followed an intense publicity campaign in the press and on radio and television, and the actual changeover was achieved relatively smoothly, though not without considerable concern by the British public.

The changeover had actually begun in April 1968 when the first new coinage, the 5p and 10p coins, entered circulation. These were larger than their successors, being the same size and weight as the old shilling and the florin or two shilling coin. A year later, they were joined by the hexagonal 50p coin, which replaced the ten-shilling note.

The old coins were gradually taken out of circulation. The old halfpenny went in 1969, and the half-crown, part of English life since the reign of Henry VIII, a year later. Most confusing for some older customers was the retention of the word 'penny', although people were encouraged in publicity to refer to 'new pence', and the similarity of the new 10p piece to the old florin.

There was a strong suspicion among Leicester's shoppers, reflecting a nationwide feeling, that decimalisation had hidden many price hikes. In fact, inflation was already at 9.4 per cent which was, in any case, driving up retail prices. In London's West End, the so-called 'anti-decimal terrorists' handed out leaflets denouncing the government's failure to consult public opinion.

In the weeks before Decimal Day, the government, the media and the world of entertainment all combined to promote the benefits of the new currency. Entertainer Max Bygraves released *Decimalisation*, the BBC organised a series of five-minute information shows with the title *Decimal Five*, and ITV broadcast a drama with the patronising title *Granny Gets The Point*, showing a baffled old lady learning how to use the new coins.

The principal issue that the publicity machine did not address effectively was the need for the public to change its thought processes. Most older people had been taught their multiplication tables at school and could therefore work out how much change to expect when, for example, purchasing shopping totalling £7s 7d and offering a 10*s* note. It was very difficult for many to then forget the twelve times table and think instead in multiples of ten, but at the same time remember for the sake of comparison that 49p was 'nearly' 10*s*.

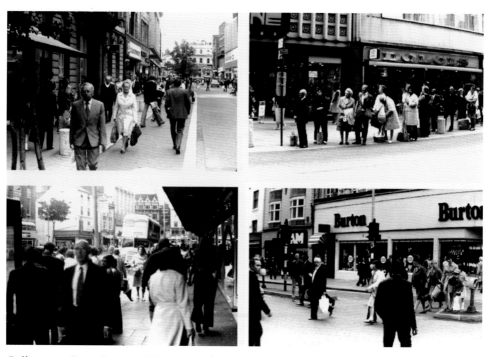

Gallowtree Gate, August 1975: Four photographs of Gallowtree Gate, between the clock tower and Horsefair Street, taken in August 1975 before the rise in dominance of out-of-town shopping centres.

On Decimal Day, the transition went relatively smoothly. British Rail and London Transport had made the change on the previous day, and most high street stores were prepared, and their staff briefed. Harrods paraded an army of 'decimal pennies', girls dressed in boaters and blue sashes, and Selfridges fielded a troop of girls dressed in, to quote the store's publicity, 'shorts and midi split skirts and other suitably mathematically designed costumes.'

In Leicester, decimal adding machines and other converters were available to help people convert their half-crowns, shillings and florins into the pounds and pennies. Shops displayed prices in both predecimal and decimal values, and when paying in old currency, received the new coinage in their change.

Decimalisation is estimated to have cost the country an estimated £120 million, about £4 billion today. It was a major social change which was the precursor to an even more significant political change which took place on New Year's Day in 1973 when Britain joined its decimalised partners in the European Community. Outside its Brussels headquarters, the Union Jack flew for the first time, upside down as the *Daily Mail's* reporters observed.

East African Asian Immigration

In August 1972, Idi Amin, President of Uganda, announced what he described as an 'economic war' which included the expropriation of property owned by Asians and Europeans living in his country. Uganda, which had been under British rule from 1894, gained its independence from the United Kingdom in 1962. General Idi Amin ousted President Milton Obote in 1971. There were about 80,000 Asians living in Uganda, mostly born in the country, their ancestors having come from the Indian subcontinent when Uganda was still under British rule. As the descendants of Indians brought over to build railways during the days of the British Empire, they had formed a wealthy mercantile class, owning shops, factories and plantations. Many ran large businesses which were essential to the Ugandan economy.

On 4 August 1972, Amin decreed that all Asians who were not Ugandan citizens were being expelled. He later extended this to all 80,000 Asians except some professionals. Some 30,000 of these men, women and children travelled to the United Kingdom. Their business and property were handed over by Amin to his favourites and supporters. Most failed due to mismanagement.

At first, many of the Asians thought that the order to leave was a joke, or simply a temporary mood swing on the part of their erratic president, but imprisonment and public beatings followed.

Leicester City Council had issued a notice in the *Uganda Argus* advising potential emigrants not to attempt to come to Leicester. It warned that there were no houses available and no jobs, and that the local schools were already full. However, most chose to ignore the council's plea, settling mainly in the Highfields area of the city.

They differed from earlier Asian and Indian immigrants because these peoples were refugees, forced from their homes, often at gunpoint, who had stepped off a plane at Stanstead with very little more than the clothes they were wearing and some cash in their pockets. Many arrived as complete families, which meant that their housing and social needs were also different.

Despite all attempts to steer them away, research has shown that the refugees were correct in their belief that Leicester was the place where they could survive and begin

to reinvest their skills. Asian businesses set up since the early 1970s now provide employment for at least 30,000 Leicester people.

Faith and Religion

The Diocese of Leicester had been aware of the increasing diversity of Leicester's population in the late 1960s and had taken some steps to extend a welcome to those of other religions who were moving in to the city. Due to their location, some churches changed their liturgy to accommodate the new cultures, such as the significant number of West Indian worshippers who began attending St Peter's. The Orthodox Church was also represented as at St George's.

But church attendance had been declining in the previous post-war decades and continued to decline in the 1970s. In 1975, about eight million people in the United Kingdom regarded themselves as members of a Christian church. By 1980, this number had fallen by almost half a million. There was a parallel decline in the number of ordained ministers, and over the decade the number of places of worship across the country fell by more than 1,000.

Commentators have proposed that this steady decline in interest in religion has been driven by the social and cultural changes which began in the 1960s. These changes challenged the prevailing moral code, and were formalised by a series of major parliamentary and legal reforms including the legalising of abortion and homosexuality, the abolition of capital punishment, and laws which safeguarded and extended women's rights. As a result, the generation which grew up in the 1970s were less likely to accept the

Emmanuel Baptist Church, 1978: The gaunt, almost gothic-styled Emmanuel Baptist Church dominated the small rows of terraced houses in Leamington Street. It was demolished in 1978, along with the surrounding streets, to make way for the extension of the Narborough Road to West Bridge.

beliefs and views of their parents, less deferential to tradition and more individualistic in their attitudes to behaviour and to definitions of right and wrong.

Leicestershire has a long history of religious tolerance and many radical religious thinkers have found a safe haven here. This attitude has enabled a diversity of Christian denominations to exist together. From the 1970s, this willingness to understand different avenues of belief has widened to embrace the many different faiths that came into Leicester in the 1970s and later, including those of the Jewish, Muslim, Hindu, Jain, Sikh and Buddhist traditions. This diversity is dramatically portrayed by Leicester's changing skyline which now includes temples, mosques and synagogues alongside churches and chapels.

In Leicester in the 1970s, a variety of redundant buildings were slowly converted to serve as places of worship for those of other faiths. Initially, acts of worship had to be held in people's homes until small communities began to coalesce and were able to hire other spaces. In 1969, the former Co-op at the corner of Chatsworth Street and Cromford Street was purchased by one such group and converted into a praying hall. As the new decade dawned, the shop became the first Hindu temple in the United Kingdom. When the Imperial Typewriter Co. closed down in 1974, a group of Muslim businessmen converted the former works canteen into a mosque, which is now one of the largest in the city.

Within the Christian churches, there was an attempt to modernise forms of worship and music in an attempt to make religion more attractive and relevant to the young generation. Christian pop groups were created; the interiors of some churches were reordered, introducing modern furniture, sometimes at the cost of destroying valuable assets from previous centuries. The phenomenon of 'trendy' vicars appeared, and in Leicester the Church of England appointed a Diocesan youth adviser. From the late 1960s and throughout the 1970s, the Revd Ian Phelps served in this role, connecting with the younger generation, particularly through *Intro*, his innovative weekly music and chat show on BBC Radio Leicester which served also to recruit and train a significant number of talented young people to the broadcasting industry.

Demolition of Belgrave Road railway station: This was the Great Northern Railway's Leicester terminus from which thousands of Leicester people would travel to Skegness and the east-coast resorts every year. Passenger services closed in 1962 and the entire line in 1969. The station building survived until 1972.

Leicester rail parcels depot, Humberstone Road: Photographed in the late 1970s, this was the dispatch point for parcels being carried via Leicester London Road station. It was located on what is now the St George's retail park near to where the present Aldi store stands. The snow-covered trailer was used for servicing the wholesale market in the early hours of the morning.

Fashion

The pop culture of the 1960s set the scene for what was to follow in a period which has been described as the decade of bad taste, the 'Me Decade' (by the American author and journalist Tom Wolfe) and as one of the most iconic decades in fashion ever.

When pressed to summarise the look of the 1970s, fashion historians will allude to a general style of 'tight on the top and loose at the bottom', but, as in other attitudes to society and culture, the young people of this era preferred to demonstrate their nonconformity in what they chose to wear. The miniskirt reached new heights in popularity but so too did hot pants. The informality of T-shirts and jeans underlined the anti-conformist approach, as did the hippy look from the United States which demonstrated the powerful influence of television in transferring cultural styles across the world.

It was still necessary to conform when it came to formal 'smart' attire. Most children in Leicester were still required to wear a school uniform, and on Leicester's high street and in Gallowtree Gate, the made-to-measure retailers such as Burtons on the corner of Humberstone Gate and Gallowtree Gate and John Collier at 15/17 Gallowtree Gate ('the window to watch') were still doing good business, particularly because of their extended interest-free finance plans, and the independent tailors were still thriving such as Jacksons, also in Gallowtree Gate. Almost all the garments sold in these stores and in the chain stores such as Littlewoods were still made in England, with a considerable percentage still manufactured in Leicester and the surrounding towns including Loughborough and Hinckley. Synthetic fabrics such as vinyl and nylon were also beginning to be used in larger quantities for the first time.

The worlds of popular music and culture brought two further fashion styles to Leicester's clubs and music venues towards the end of the decade in the form of disco

Leicester barmaids: This photograph is arguably not representative of Leicester's bars and clubs in the 1970s, but barmaids in hot pants were for some commentators indicative of social attitudes of the time.

and punk. These two styles were arguably at the opposite ends of the pop-culture spectrum. With its emphasis on glitter and body shape, disco will forever be epitomised by the music of the Bee Gees and the dance imagery of the 1977 blockbuster *Saturday Night Fever* but was a style that inherited much from the previous decade. Punk was far more a rejection of past traditions and the imagery of nonconformity including ripped clothes, tight leather trousers and numerous embellishments such as chains and studs, offensive slogans, safety pins and Dr Martens. At least the sudden popularity of the latter was of great benefit to the footwear trade in the East Midlands, particularly Northamptonshire!

As with earlier similar fashion expressions such as the teddy boys of the 1950s, as soon as punk became more than a clique style it was modified and made tamer, becoming what was described in the 1980s as 'new wave'.

Holidays

The popular song 'Let's Get Away From It All' was written in the 1940s but was somehow most appropriate to the 1970s when families began to break away from the traditional day at the seaside and chose to escape from the industrial strife by flying to foreign resorts. Previously, the railways had transported Leicester's workers en masse to seaside resorts such as Skegness, often in organised parties linked to the major local industries. But although the Leicester Industrial Fortnight, in the first two weeks of July, still held sway during the 1970s, many more people were able to break away from the holiday tradition and travel much further afield. The package holiday business mushroomed in scale in just a few years, offering the experience of a lifetime for millions of people who had never travelled abroad before, or even been on an aircraft.

By the end of the decade, over 13 million British people were holidaying abroad in resorts on the developing Greek Islands, the Costa de Sol and in Majorca. The package holiday had been created which offered a sense of some adventure but in a fully organised package. It was Butlins with guaranteed sunshine. Two weeks full-board in Majorca could cost as little as £50.

As car ownership increased, so did the popularity of the caravan holiday. Again, there was this illusory sense of breaking away from the crowd and being independent, of leaving the workplace and the workmates behind and choosing where to go and when to go. Children would squeeze in to the back of the small family car, without seatbelts, but with many arguments as to who would sit next to the windows for journeys to the coast, not only to the east coast but north to resorts such as Rhyl and Llandudno. Of course, these new holidaymakers were still going with the crowd: they would stay in large uniform caravan parks, shop in the same park shop and eat and drink in the same camp centres every night. On the way, there were the inevitable traffic jams as the older trunk routes struggled to accommodate the sudden increase in vehicles.

But the world was getting smaller. As the UK motorway network expanded, the family car could travel much longer distances in less time. For those with a much wider vision, the development of Concorde, the world's first and only supersonic airliner, brought Washington and New York to within three hours of flying time by 1977.

St George's Church: The first church built in Leicester since the Reformation; in the 1970s, it became redundant but found a new life as the religious home for Leicester's Serbian Orthodox Christians.

St George's Tower: Eighty-two metres in height and standing on high ground, St George's Tower reaches further into the sky than any other building in Leicester. Spraying the grey concrete in blue failed to relieve its dark and gaunt presence.

8

OVER THE HORIZON

When the lights went out, and the household refuse was lying piled up on the pavements, and workers were at home, laid off because of an enforced three-day working week, many Leicester people wondered whether life in the 1970s could get any worse. Many doubted whether the politicians of any political persuasion had the ability to address the underlying issues and thus the political pendulum of the decade swung from left to right and back again – and again.

The approach to solving the economic problems – the soaring inflation, rising prices and growing unemployment – also changed, but the old economic debate continued. Was the solution a tighter control on wages, or a laissez-faire approach? Should there have been more encouragement from central government for Leicester's traditional industries to invest in more up-to-date equipment, technology and working practices? Should there have been a control on the cheap foreign imports which were damaging our manufacturing base?

Politically and economically, the 1970s was a turbulent decade. The industrial strife resulted, even in the normally peaceable Leicester and Leicestershire, in outbursts of violence as the widespread strike actions began to affect both those who had withdrawn their labour and those who depended on that labour. Leicester people who traditionally looked forward to the new year, and the turn of the decade, no doubt hoped that the 1980s would be different, more harmonious and more prosperous than the immediate past, but that was not how the future developed either locally or nationally.

It is perhaps too close in terms of time and the passing of the years to understand fully and objectively the legacy of the 1980s in Leicester. Whereas it is relatively easy to ascribe a characteristic (albeit somewhat clumsily) to the previous decades, such as the post-war austerity and rebuilding of the 1950s, the dramatic social revolutions of the 1960s and the naïve fresh modernism of the 1970s, the years that followed still seem undefined.

With the benefit of hindsight, much of the development and innovation of the 1970s was to be short lived. Many of the buildings that were constructed during that decade would not last, not only because of their design and the way in which they were constructed, but because of a lack of imagination, which rendered them useless in the twenty-first century. Leicester's indoor market is an example of a modern design that failed to cope with the changing demands and expectations of shoppers and car drivers, and consequently it was demolished in 2015. A consideration of some of Leicester's housing built between 1950 and 1980 underlines the truism that all hastily constructed housing designed to a limited budget and with restraint on space have the potential to become the slums of the next generation.

The 1970s were not a good time for health and well-being. We were yet to be fully aware of a healthy diet and the need to keep fit. Convenience food was growing in

The Attenborough Building, Leicester University: Opened formally by John Attenborough, the youngest son of Frederick Attenborough, this was the last of the three high-rise buildings to be constructed on the Leicester University campus, completed in 1970.

Our Lady of Good Counsel, Gleneagles Avenue: A rare example of 1970s architecture in Leicester which is of the right scale. The building has symmetry from only one perspective but offers many fascinating visual contours from other angles.

popularity with the expansion of the supermarkets, and less people were growing their own fruit and vegetables. Social attitudes to mental health, homosexuality and feminism were still rooted in the past and the popular social attitudes reflected these biases. Although the previous decade had produced a revolution on sexual freedom and a blurring of class and race distinctions, apart from young activists these movements went unnoticed by most people in the 1970s and the following decade.

There was certainly much international political drama in the 1980s. On the international front, we saw the collapse of Eastern European communism, leading to the consequent ending of the Cold War, the collapse and removal of the Berlin Wall and the reunification of Germany. In the United Kingdom and the United States, conservatism was in the ascendant in political and cultural life, led by Margaret Thatcher and Ronald Reagan. The former was able to show her resolve and determination as a leader in reoccupying the Falkland Islands after they had been invaded by Argentina in 1982.

China was continuing to grow and to become more welcoming of Western ideologies, but the old Communist guard was still nervous and sometimes irrational, as was demonstrated in the brutal crushing of the student protest in Tiananmen Square on 4 June 1989. Also, that uneasy relationship between international sport and politics came back to the fore in both 1980 and 1984 with boycotts of the Olympic Games by a number of world powers.

Cardinal Building, July 1972: Built before the digital revolution, when telephone exchanges needed large floor space, the Cardinal Building in Humberstone Gate takes centre stage in this view of Leicester from the roof of Epic House.

Cardinal Building, July
2015: The Cardinal Building
towers above the remnants of
Leicester's Victorian past. Of the
high-rise developments in the
city in the 1960s and 1970s, this
remains an impressive landmark.

In many ways, the 1950s looked back to the anxieties and stresses of the Second
World War, the 1960s were a reaction against those historic restraints and inherited
prejudices and the 1970s witnessed a tangible desire to be modern and think
progressively. But it appears from the present perspective that everything then faltered.
Arguably, it was the election of Margaret Thatcher as Prime Minister, serving from
1979 until 1990, that changed our outlook on many aspects of life. Her rise to
distinction and power would not have been possible in the social and political climate
of the preceding decades, and even now we tend to look at modern British political and
economic history as being pre- or post- Thatcherite years. We are yet to understand
fully how significant her policies, and that of her governments, were to be on the future
of Leicester and of the country.

But in other ways, the 1980s would develop in much the same way as the preceding
decade. The familiar attitudes and assumptions would prevail including a continuing
male-bias in the workplace and elsewhere. There would also be the attraction of widening
horizons stimulated by technological advances. The first Apple Mac computer went on
sale in 1984, the first 'dot com' website business address was registered in 1985, and the
worldwide web was formed by 1989. After that moment, life for all of us, anywhere in
Leicester and Leicestershire, would, most definitely, never be the same again.

Belgrave flyover site 2015: The removal of the flyover has created a wide-open landscape which has some echoes of the vistas that existed before its construction including the Wolsey building. The flyover was originally seen as a project that would connect the 'Golden Mile' with the city; in reality it created its separation.

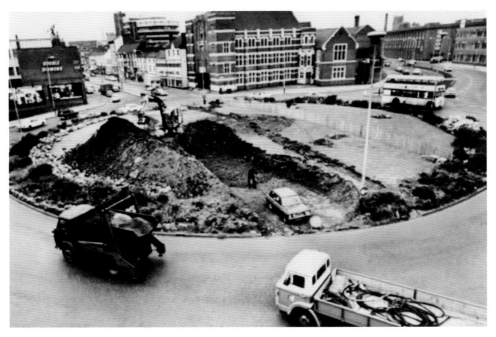

Belgrave Gate, 1970: A view of the junction of Belgrave Gate and Burley's Way before the flyover and St Matthew's Way had been constructed. (*Leicester Mercury*)

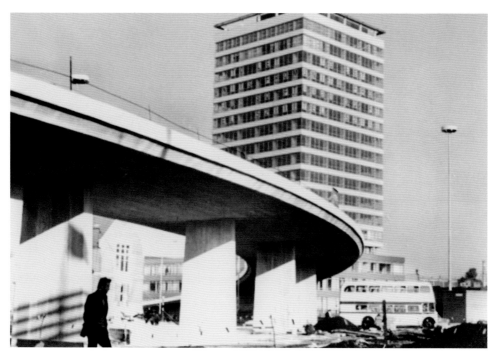

Belgrave Gate, 1976: The flyover comprised the last section of the Central Ring, with St Matthew's Way, cutting through part of the old Wharf Street area, connecting with St George's Way and the A47 Humberstone Road.

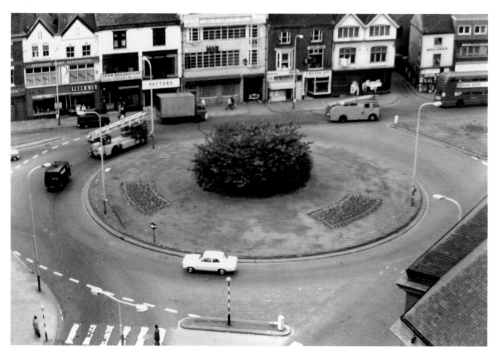

Belgrave Gate roundabout, August 1972: Fire engines responding to a 999 call and a Midland Red double-decker bus heading towards Abbey Street.

Above: Belgrave Gate Roundabout, July 2015: The roundabout is no longer discernible in the construction work which is part of the new 'Connecting Leicester' project. The cluster of shops in the background has not changed so dramatically.

Right: Haymarket Shopping Centre Opening: After several years of city centre disruption, and the rebuilding of a significant segment of the shopping area involving Humberstone Gate, the Haymarket and Charles Street, the Haymarket Shopping Centre opened in June 1973. Despite the size of the overall construction, the central piazza looks remarkably small.

SOURCES

Amos, D., *The Nottinghamshire Miners, the Union of Democratic Mineworkers and the1984-85 Miners Strike: scabs or scapegoats?* (Unpublished PhD thesis).
Beasley, B., *Post-war Leicester* (The History Press, 2006).
Bennett, J.D., *Illustrations in the Architectural Press of Victorian and Edwardian Buildings in Leicester*, in Transactions of the Leicestershire Archaeological and Historical Society (TLAS), vol. 59, 1985.

Centenary History of the School of Textiles (Leicester Polytechnic Press, 1983).
Financial Analysis Group Ltd, *A Business Survey of Leicester and its companies* (Financial Analysis Group Ltd, 1972).
Griffin, C., *The Leicestershire Miners, Vol III, 1945-1988* (NUM Leicester Area, 1989).
Hansard, *Knitting Machinery debate, HC Deb 20 December 1974*, vol. 883, cc2050-8.
Hutchinson, R. N., *The Mile Straight: the Fate of the Soar in the Centre of Leicester* (published by the author, 2008).
Lambert, D., *The History of Leicestershire County Cricket Club* (Christopher Helm, 1992).
Leicester – A Special Report, the *Times*, 15 December 1969.
Mander, J., *Leicester Schools 1944-1974* (Recreation and Arts Department, Leicester City Council, 1980).
Mitchell, D., *Leicester Squash Club: The First Seventy-five Years* (Matador, 2013).
Simmons, J., *Leicester and its University* (Leicester University Press, 1963).
Williams, C., *Bishop's wife but still myself* (George Allen and Unwin Ltd, 1961).
Williams, D. (ed.), *The Adaptation of Change: Essays upon the history of 19th Century Leicester and Leicestershire* (Leicestershire Archaeological and Historical Society and Leicestershire Museums, Art Galleries and Records Service, 1980).

ACKNOWLEDGEMENTS

I must record my gratitude to the many Leicester people who have contributed facts and figures, comments and criticism during the process of writing this book. These interactions have ranged from a brief email to an extended conversation, from a confirmation of a date to the provision of source material and photographs. All have been essential in completing this project. Liz Coulter and Andrew McCloud confirmed the details of Leas' department store. Bob Kemp and Chris Jinks of the Leicester Transport Heritage Trust read the draft text and offered many helpful comments and suggestions. David Mitchell provided information regarding squash and golf in the city.

I acknowledge the ownership and sources of the photographs reproduced in this book which include Robert Smith, P. Vyse-Widdicombe, Denis Calow, John Daniell (Leicester Museums Service), the Inlands Waterways Association, the *Leicester Mercury*, the University of Leicester, BBC Radio Leicester and De Montfort University and the archival source of some of these images, in particular the Special Collections Department of the University of Leicester.

However, interpreting and collating this information has been my task, and my responsibility, and any errors or misinterpretations that remain are mine alone.

No history of a time or a place can stand alone. The historians of today depend upon the work of those who recorded the past, and I am pleased to acknowledge the influence of all the works I have consulted. Above all, it is of course the people of Leicester who have made this book possible. Without you there would be no stories, no buildings, no images and no future.